IMAGES
of America

RIVERTON

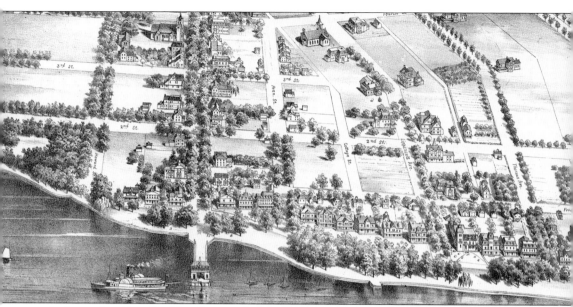

Lithographer Otto Koehler illustrated a riverbank studded with founders' homes, a steamboat landing, and the Riverton Yacht Club in this 1890 bird's-eye view of Riverton. The founders were largely Quakers and wealthy merchants who sought to establish a scenic summer refuge in the country—an escape from the heat and pressures of city life. They commissioned noted architect Samuel Sloan to lay out their 10 "villas" to be built along the riverbank, all with unobstructed views of the Delaware River. Sloan's innovative plan included 105 building lots of many sizes, streets, a walled and landscaped riverbank, a pier for the steamboat landings, a railroad station at the other end of town, and a small general store. As the town expanded and families made Riverton their year-round home, the yacht club was officially founded in 1865, and the clubhouse on the pier was completed in 1880. (Courtesy of the Historical Society of Riverton.)

ON THE COVER: The Riverton Yacht Club is pictured on Labor Day weekend in 1946, just a year after the formal end of World War II, and all eyes are on a bright future. This is the start of the first national regatta of the Duster-class boats designed in Riverton during the Depression to be easy to build at home. Thirty-five boats were entered. (Courtesy of the Historical Society of Riverton.)

IMAGES
of America

RIVERTON

Historical Society of Riverton
Foreword by Roger Prichard

ARCADIA
PUBLISHING

Published by Arcadia Publishing
Charleston, South Carolina

Printed in the United States of America

Library of Congress Control Number: 2022932526

For all general information, please contact Arcadia Publishing:
Telephone 843-853-2070
Fax 843-853-0044
E-mail sales@arcadiapublishing.com
For customer service and orders:
Toll-Free 1-888-313-2665

Visit us on the Internet at www.arcadiapublishing.com

The great Roman statesman Cicero observed that "not to know what happened before one was born is to be always a child." We dedicate this first book about the history of Riverton to all those preceding us who have contributed to Riverton's unique character.

CONTENTS

FOREWORD

Most small towns have a distinct character, but Riverton, New Jersey, has been an unusual—even an unlikely—little village right from its founding in February 1851.

The first town in America to be built as a planned suburb for summer folks, it sprang from sparsely populated farmland and remains a charming rarity in the modern world, a place where people put down roots and care deeply for their history.

Riverton's founding was not only unexpected, it also came with a couple of mysteries that have not been satisfactorily explained: Why were all 10 of the founding families active abolitionists? And how did they build so much in such a short period of time?

The reason for starting the town was to create a quiet summer village close enough to Philadelphia that the residents could retreat from the city's stifling heat and disease but commute daily on a smooth steamboat ride to the front door of Philadelphia's business district.

Most of the founding families had businesses in Philadelphia, and every family was active in the sometimes dangerous effort to abolish the institution of slavery. The Fugitive Slave Act of 1850 had just been passed, making their already busy lives even more chaotic. Why they would choose this time to create a summer resort is unclear.

The second mystery is how the founders accomplished what they did in just a few months. They transformed empty farmland into 10 landscaped riverbank villas, many smaller buildings, and a stone seawall, almost all before even completing their new steamboat wharf. How did they ship the materials and recruit a small army of carpenters, masons, plasterers, painters, laborers, and others—and where did they house them, and how did they feed them? We do not know.

Over the next decades, many others joined the Quaker founders. They had other beliefs, ethnicities, and a wide range of occupations, from laborers to wealthy industrialists. The town slowly expanded from a summer "place of resort" into the year-round village of today, still just three-quarters of a square mile.

The Delaware River was the town's front door from the start and is still the heart of Riverton's identity, a place for sailboats, kayaks, pleasant walks, and the best sunsets this side of Key West.

Come along as we explore what life was like for this hidden little place of historic homes and the families who loved them.

Roger T. Prichard
Riverton Borough historian

ACKNOWLEDGMENTS

This book is the result of the combined effort of the Historical Society of Riverton (HSR) board members and many fellow citizens and friends who share our love of local facts, legend, and lore. This book is meant to be viewed as a mosaic of images, little glimpses of the past to help us find our place in history.

After Betty Lockhart proposed forming a historical society in 1970, a total of 54 people met at her home and voted to form such an organization. Before and since then, other influential persons have contributed significantly to the preservation of our town's history. We owe particular gratitude to the following individuals for their support in this project.

More than any other single person, Betty B. Hahle has made our understanding of Riverton history what it is today. By so faithfully documenting Riverton's past with her meticulous investigating and record-keeping, she has assured her place in Riverton's history alongside the very founders, merchants, industrialists, and social activists she researched and is certain to be quoted and cited for years to come.

Special mention is due to William Probsting, an HSR board member who passed away during the writing of this book, which interested him greatly.

William Brown, a former mayor of Riverton and our stalwart HSR president, has supported and encouraged us to the finish line.

Roger Prichard, our current borough historian, is a dedicated researcher with an insatiable curiosity and urgency to "get it right." His uncanny ability to connect the odd bits of disjointed history into a coherent story, his fact-finding, and his double-checking have held us all to a high standard.

Our website and newsletter editor, John McCormick, has researched Riverton's history for 20 years. His compilation of images collected from many people, combined with those from his collection, comprises a great deal of this book.

Nancy and Bill Hall shared many photographs from their own collection and provided invaluable historical context to many of our archived images.

Faith Endicott, a relatively new HSR board member, boldly proposed that we might do what no one had tried in our 50-year history—creating a book about Riverton from our perspective. Her infectious enthusiasm for the project won everyone over, and here we are. We have a book. And it is largely due to Endicott's leadership and determination.

The content presented in this book is a result of the collaboration of project manager Endicott and researchers McCormick and Prichard, who depended heavily on the work of countless others who have contributed to our understanding of Riverton's history.

The additional HSR board members who were instrumental in helping to organize this book are Keith Betten, Pat Brunker, Susan Dechnik, Edward Gilmore, Iris Gaughan, Martin Hain, Heather Huffnagle, John Laverty, William McDermott, Tyler Putman, Phyllis Rodgers, and Patricia Solin.

Finally, thank you to all former and current HSR members and to everyone who has supported the mission of this organization to "create an awareness of our heritage, to discover, restore, and preserve local objects and landmarks, and to continue to expand our knowledge of the history of the area."

Unless otherwise stated, all of the images in the book appear courtesy of the Historical Society of Riverton.

INTRODUCTION

Riverton had no local government at the time of its founding, but a desire for self-governance rose as more of its residents lived in the area year-round. It was originally part of Chester Township, which included everything between the Pennsauken and Rancocas Creeks from the Delaware River to Mount Laurel.

In 1865, Chester Township split, and everything that was not present-day Moorestown became Cinnaminson Township. In 1893, Rivertonians voted to become independent, electing Edward H. Ogden to be the Borough of Riverton's first mayor as well as electing a four-man borough council.

The town's new firehouse served as a meeting space and continued as such until 1989, when a new municipal building was erected. The Historical Society of Riverton donated the lights at the building's entrance, which were saved when the old railroad station was torn down.

The townsfolk established churches here early, with the first being Christ Episcopal. That church's Main Street facade is graced by a Louis C. Tiffany rose window given in memory of longtime summer resident Louis Godey, the publisher of America's first women's fashion magazine. More churches soon followed: Sacred Heart, Calvary Presbyterian, and Mt. Zion AME.

Riverton's public school was a central part of town life from the beginning, and various civic organizations and activities soon sprang up, including the Riverton Fire Company, the Porch Club (a women's club active in making many social improvements happen in Riverton and beyond), lectures and arts programs at the Lyceum, and sports leagues.

Today, Riverton is a community of stability. The population is about 2,700, with about 1,000 households. The governing officials are all unpaid volunteers—a mayor and six borough council members, plus appointed committees, commissions, and boards.

The center of town still holds a small business district along with tea and coffee shops, restaurants, a fitness center, a drugstore, a post office, and a bank, among other establishments. It is a habit of Rivertonians to walk around town, and many of these amenities are conveniently able for one to reach by foot. The wider world beckons. For the past 20 years, the River Line light rail service has taken riders from Riverton to Camden with connections to Philadelphia and Trenton with trains to Newark and New York.

Riverton is still the same three-quarters of a square mile that it was in 1893, and the borough's neighborhoods are an encyclopedia of American architectural styles. More than 350 of Riverton's buildings are individually listed in the National and New Jersey Registers of Historic Places. With its expansive grassy riverbank, fine old trees, and some streets still lit by gaslights installed a century ago, Riverton is a wonderful place to live.

A NOTE FROM THE MAYOR

Riverton is what comes to mind when one thinks "small, historic town." According to architectural historian Henry Russell Hitchcock, Riverton was the first totally planned residential subdivision in America. We have wide, tree-lined streets and brick sidewalks. Homes built by the founders in the Victorian era still stand overlooking the scenic Delaware River. Sailors still sail the river from Riverton Yacht Club, the oldest yacht club on the Delaware. Gas streetlamps light the way at night.

Almost every home and building you see in this book still stands today. Whether you have just discovered Riverton or have lived here for 5 years—or 50—you will learn fascinating things about our town and the people who lived in the buildings you walk by every day. In Riverton, you can live our history every day.

Suzanne Cairns Wells
Mayor of Riverton
2021

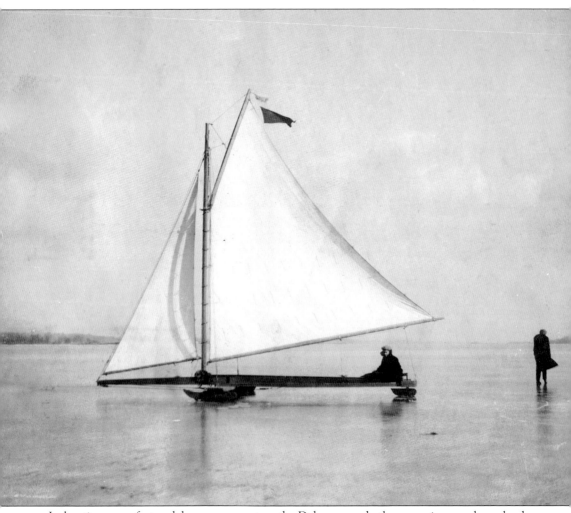

Iceboating was a fast and dangerous sport on the Delaware and other area rivers and ponds when they froze over. The competition was as fierce as the weather was cold. Riverton had several daring sailors who brought their boats and sailing skills to new heights. In this c. 1900 photograph, H. McIlvain Biddle poses with his craft that he likely stored in his carriage house in the off-season.

One

FOUNDERS AND EARLY PROMINENT CITIZENS

Three fascinating people can be traced to the home at 305 Bank Avenue: two Riverton founders—J. Miller McKim and Charles Dexter Cleveland—and Charles A. Wright. McKim served as manager of the Pennsylvania Anti-Slavery Society and was active in the Underground Railroad. An academic and an ardent abolitionist, Cleveland organized the largest slave escape in the history of the United States, founded the Republican Party in Pennsylvania, and was Lincoln's consul to Wales. Wright established the Tacony-Palmyra Ferry Company in 1919, masterminded the building of the Tacony-Palmyra Bridge, and served Riverton in many civic and social capacities. The house was moved to 102 Penn Street around the time of World War II.

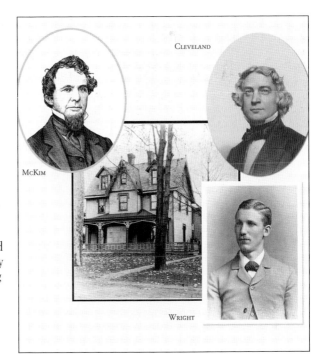

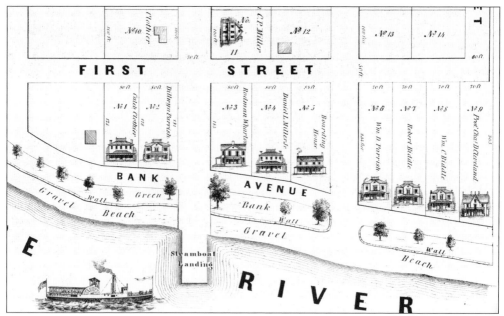

The 10 founders of Riverton purchased 120 acres of farmland from fellow Quakers Joseph and Beulah Lippincott in February 1851. Noted architectural historian Henry Russell Hitchcock called it "the first wholly planned residential subdivision in America." This unique map owned by the Riverton Porch Club of Riverton shows the founders' homes and the steamboat wharf, all of which were completed by September 1851.

Hardware merchant and real estate entrepreneur Robert Biddle was a founder of Riverton and a fervent abolitionist who later served as the treasurer of Swarthmore College. He and his wife, Anna Miller Biddle, used 309 Bank Avenue as a summer home for decades. Robert moved to Riverton permanently after Anna's death, living there for more than 50 years. His brother and Anna's sister lived on one side, and Anna's other sister lived on the other. Overall, 8 of the 10 founding families were related to 1 or more of the other families.

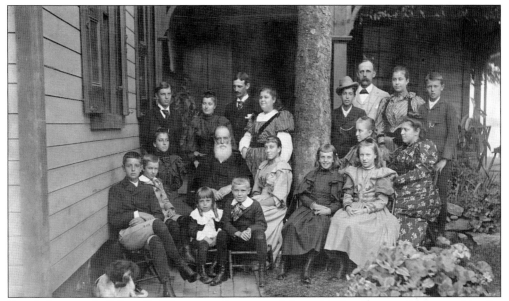

Bearded patriarch Robert Biddle is seated at center-left in this family portrait captured in the mid-1890s in the back of 309 Bank Avenue. Directly behind him are his granddaughter Anna Mary Biddle Atlee and her husband, Joshua Woolston Atlee. Most of the rest of the people shown here are likely Robert's grandchildren and great-grandchildren.

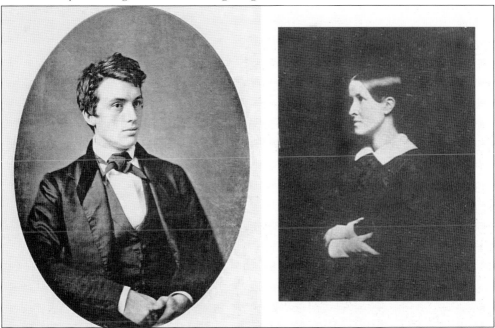

Susanna Parrish Wharton was married to Rodman Wharton, one of Riverton's founders, and lived at 407 Bank Avenue. After Rodman's tragic death when Susanna was 26, she devoted the rest of her life to social causes, including abolishing slavery, eliminating the death penalty, educating the poor, and reducing the miseries of prisoners and the insane. Among her siblings are William and Dillwyn, also founders of Riverton (William lived at 311 Bank Avenue and Dillwyn at 501 Bank Avenue); and Edward, the first president of Swarthmore College.

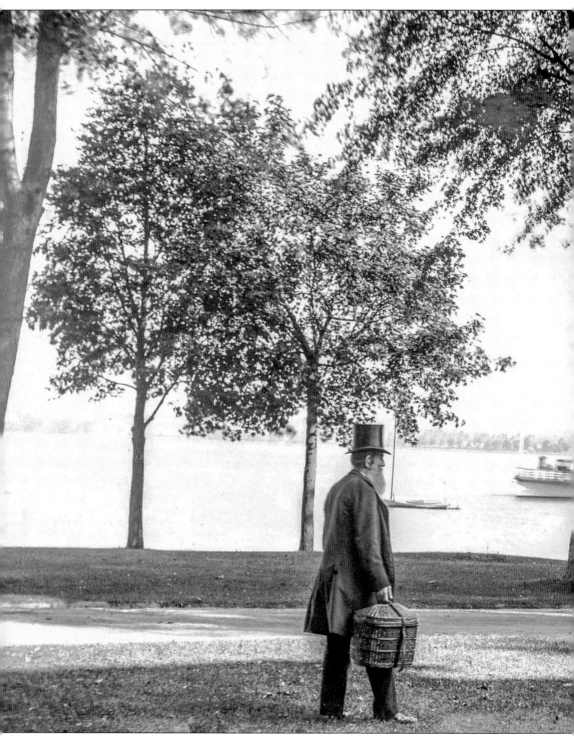

Until the early 20th century, the steamboat remained one of the main ways to commute to and from Philadelphia. In this rare photograph reproduced from a glass-plate negative around 1895, Robert Biddle leaves his home at 309 Bank Avenue while the morning boat bound for the city

arrives at the end of the Riverton Yacht Club pier. First conceived as a summer refuge, the growing village soon became a permanent home to many.

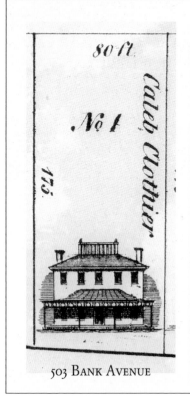

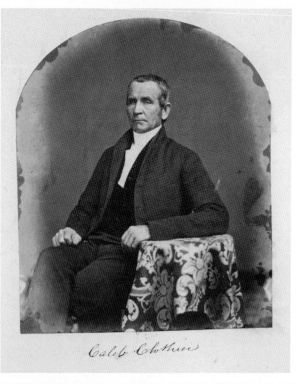

503 BANK AVENUE

Caleb Clothier

Caleb Clothier, like the other Riverton founders, was an overachiever. He was deeply involved in the abolition movement, had the most real estate development experience of any founder, and ran several successful businesses. As a bricklaying contractor, he built the masonry of the abolitionists' beautiful Pennsylvania Hall in Philadelphia, which was burned by a pro-slavery mob in 1838. The Clothier mansion still stands at 503 Bank Avenue.

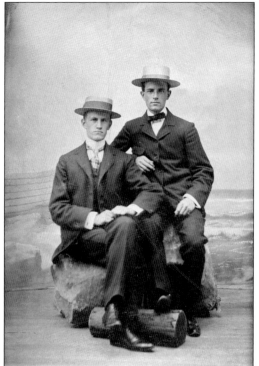

Walter Clothier (left) and Henry Parrish, each sporting the popular straw boater hat fashion of the day, are the "Best friends at Swarthmore College" to whom the caption on the back of this image refers. Walter was the grandson of Caleb Clothier and Hannah Hallowell Clothier. Parrish later married Bertha Lippincott (daughter of Ezra) and lived at 901 Thomas Avenue.

Robert Biddle and some of his family members posed at 309 Bank Avenue in 1896. Pictured here are, from left to right, (first row, seated) Hannah McIlvain Biddle, Robert Biddle, and Anna Biddle Atlee (holding daughter Clara); (second row, standing) Charles Miller Biddle and Anna's husband, Joshua Woolston Atlee. Charles is Robert's son, and Hannah is Charles's wife. Anna is Charles and Hannah's daughter. Charles and Hannah lived in the grand mansard roof mansion at 207 Bank Avenue for decades. The Atlees built their home at 100 Linden Avenue.

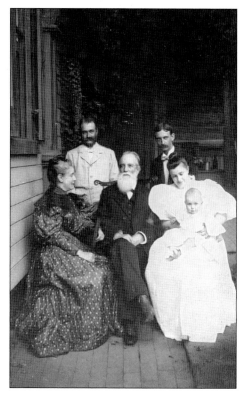

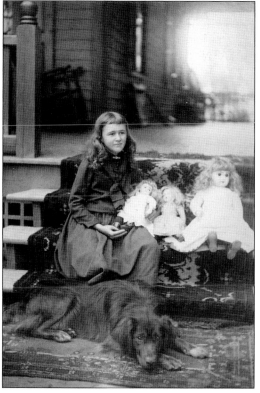

Katie Reese, pictured around 1887 along with three of her dollies and her Irish setter, is sitting on the porch steps at the house where she grew up. At that time, the house faced the river at the foot of Fulton Street (it was later moved to 201 Fulton Street). Katie's father, Mathew Mesier Reese, was a merchant in Philadelphia as well as the organist at Riverton's Christ Church. The house had been home to founder Daniel Leeds Miller Jr. and his family for about 20 years.

Helen "Elsie" Biddle holds the reins in the carriage in front of her grandfather Robert's house at 309 Bank Avenue. Helen was born in 1875, so she was about 20 years old when this picture was taken. She later became a nurse and served in France in World War I. The house next door (with the flag in front) is 311 Bank Avenue; at that point, it was a guesthouse named the Red Gables,

home of retired Civil War general William L. James. William's wife, Anna, and their daughters probably ran the inn-keeping business. One of William's daughters married John Houghton Reese (brother of Katie, who is pictured on the bottom of page 17). The *Philadelphia Inquirer* called John Houghton Reese "one of the best sailors ever developed at Riverton."

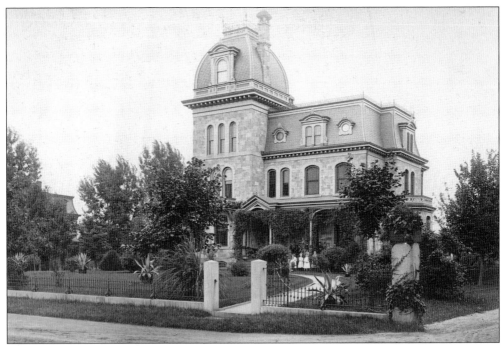

Charles Miller Biddle's Empire-style mansion was built around 1876 and featured a facade of Pennsylvania's unique green serpentine stone and a first-floor ballroom made with oak from Germany's Black Forest. Charles was the son of Riverton founder Robert Biddle and served as president of the Supplee-Biddle Hardware Company in Philadelphia.

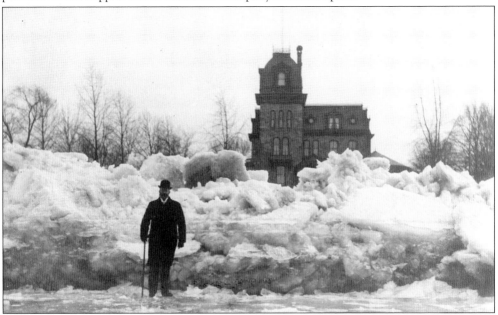

This unique photograph from about 1900 shows Charles Miller Biddle on the frozen Delaware River with his home at 207 Bank Avenue in the background. He lived in this mansion for 44 years, and it is still one of Riverton's most distinctive homes. Sadly, the top floor of its tower was lost to a fire in 1978.

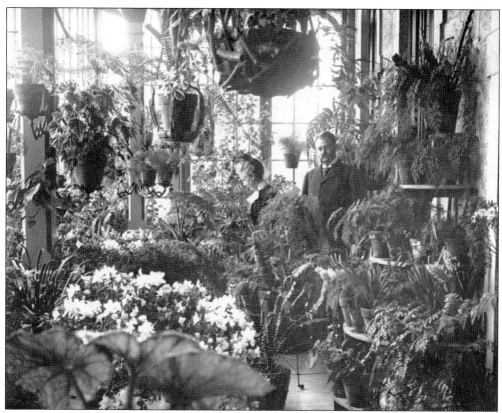

Hannah and Charles Biddle stand in the grand conservatory located on the back of their home at 207 Bank Avenue. The Biddle property also included a carriage house and icehouse. Much later, in 1942, a separate smaller home (10 Lippincott Avenue) was constructed for their elderly unmarried daughters, Elsie and Mattie Biddle, when the main house became unmanageable for them.

The icehouse behind the main house on Bank Avenue was later recognized as 2 Lippincott Avenue. It was not only used to store and provide ice but also produced a type of flammable coal gas and pumped it over to light the main house. In the 1940s, Ted Hunn and his wife, Bernice (also known as "Bunny"), subdivided the lot and converted it into a home.

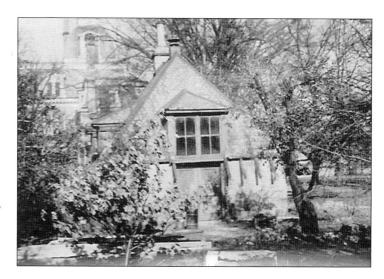

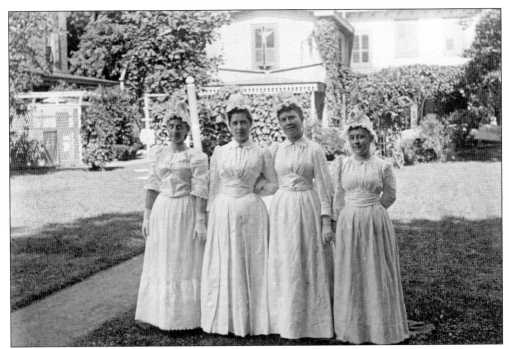

The grand villas could not exist without a considerable workforce of people toiling behind the scenes, largely invisible to the wealthy residents and seldom photographed. The four maids shown above were probably Irish and worked in the home behind them at 405 Bank Avenue in 1891. Mifflin Stevenson, pictured below, worked as a porter in Stiles Drug Store at 606 Main Street.

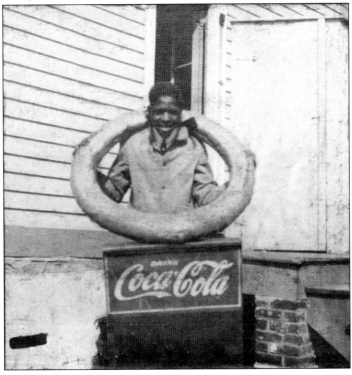

Kate McLyndon served as head cook for Ezra Lippincott and his family at 303 Bank Avenue for many years. Ezra built a cottage on the Lippincott property for Kate and her husband, the coachman. Legend has it that Kate, a colorful character by many accounts, once admonished the local priest who came to visit because he hooked his heels over the rungs of her brand-new wood settee.

Jacob Hungridge, shown here with his wife, Mary, worked as a gardener for wholesale grocer Charles Cooper Miller and his wife, Hetty Coale Lippincott, who lived at 101 Lippincott Avenue. According to the 1915 census, Jacob and Mary had three children and lived in the apartment over the carriage house, which sits at the address now called 301 Carriage House Lane.

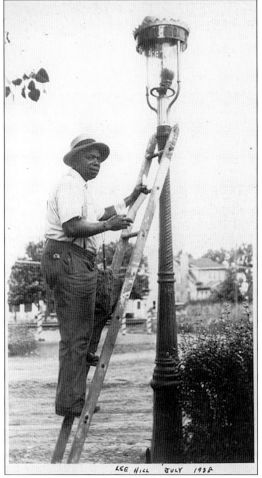

As the population in town grew, residents needed to have light on the streets at night. A subscription project resulted in the installation of some 50 kerosene street lamps in 1880. A lamplighter lit and extinguished them each day and cleaned the soot from the glass globes. The borough installed the first gas streetlamp on Lippincott Avenue near Broad Street in 1908. Shortly thereafter, Riverton installed 51 Welsbach Boulevard lights that utilized the improved incandescent gas mantle invented by Austrian chemist and engineer Carl Auer von Welsbach.

Lee Hill worked as the lamplighter and repairman in Riverton from the early 1900s until the late 1940s, when he retired.

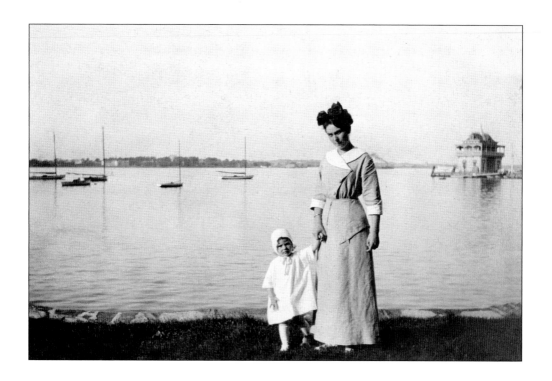

The unobstructed view and green space between the homes and the riverbank were created by design. The founders' intentions, enshrined in the earliest deeds, stated that nothing would be constructed on the riverbank that might impede anyone's panoramic views of the river. Above, a nanny and toddler pause along the riverbank around 1900.

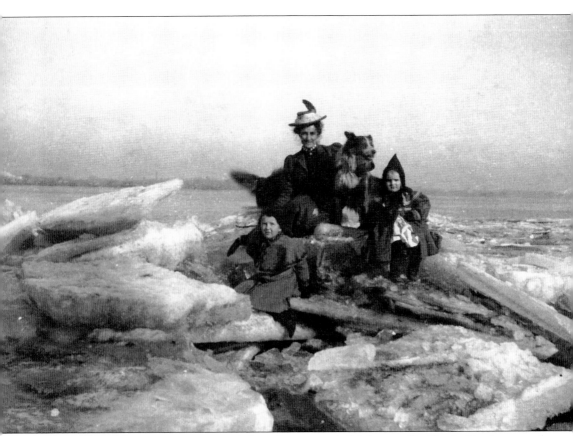

Regardless of the seasons, townspeople love the river and all it has to offer. Bertha Lippincott and her dog Belvis, along with Bertha's nieces Anna and Betty Miller, bravely pose on a pile of ice at the river's edge around 1900. The river would prove to be the stage on which many dramas—great and small—would unfold.

Two

THE RIVERTON YACHT CLUB AND LIFE ON THE RIVER

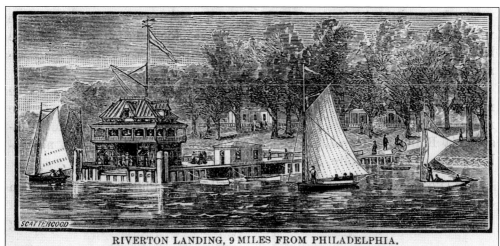

RIVERTON LANDING, 9 MILES FROM PHILADELPHIA.

Riverton almost certainly saw recreational sailing from its early years, and the first race surely took place as soon as there were two boats on the river. Interest boomed, and the need for a more conducive meeting place and general storage soon became obvious. The Riverton Yacht Club built its iconic clubhouse in 1880, and it included a waiting room for steamboat passengers. This woodcut is the oldest known image of the clubhouse and was made when it was very new. The Riverton Yacht Club is the oldest club of its kind on the Delaware River, the oldest in New Jersey, and one of the oldest in the United States in continuous operation.

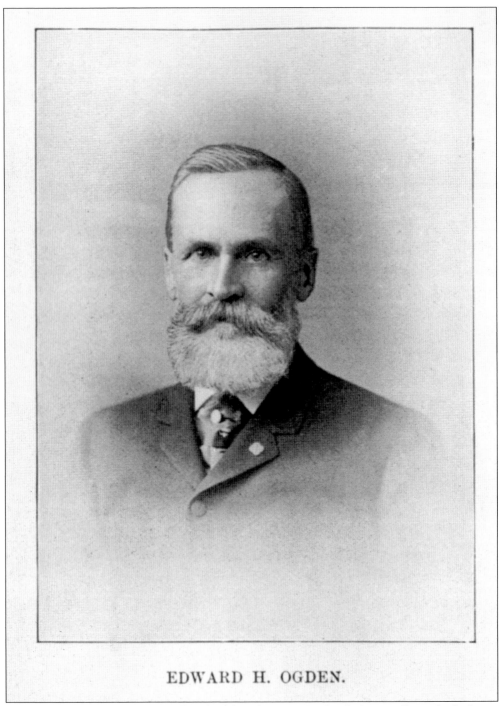

EDWARD H. OGDEN.

When some boat owners met at Edward Ogden's home at 503 Bank Avenue (formerly the home of Riverton founder Caleb Clothier) to consider establishing a local yacht club, the decision was unanimous, and by July 1, 1865, the club was officially formed. Ogden's accomplishments spanned across many parts of the community, including being elected the first mayor after Riverton became independent from Cinnaminson in 1893.

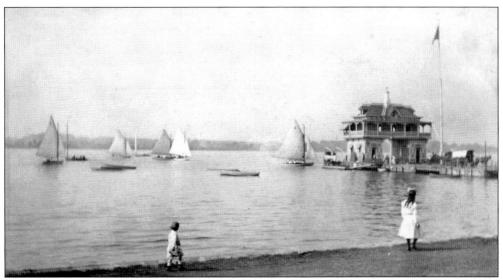

Sailboats ghost along trying to race in a light summer easterly breeze at the Riverton Yacht Club in this photograph from around the 1920s. The club not only served as a beautiful and dramatic backdrop for countless photographs through the years but also as a community destination for watching races and other water sports in all seasons, especially summer.

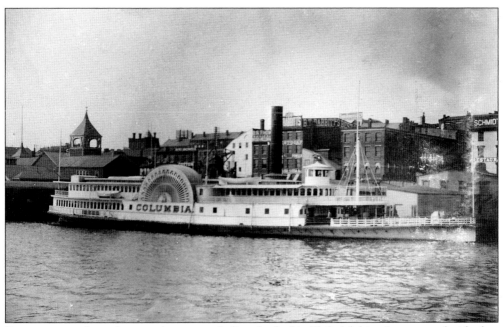

Rivertonians taking the steamboat to work disembarked in Philadelphia after a smooth ride that took about 50 minutes. Riverton boats landed at this wharf at the foot of Chestnut Street, close to all businesses in town. This rare photograph—the only known image of one of the boats at that wharf—was taken around 1890 by someone aboard another boat.

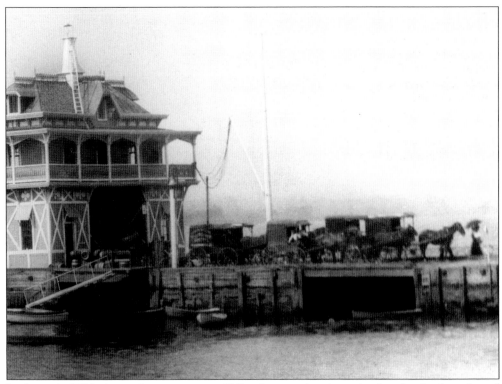

In the early 1900s, horse-drawn wagons still lined up on the pier to load and unload goods and supplies. Some of the Riverton founders eventually made it their year-round home, but often, their businesses still operated in Philadelphia, so they traveled by steamship to work and call on family and friends who remained there.

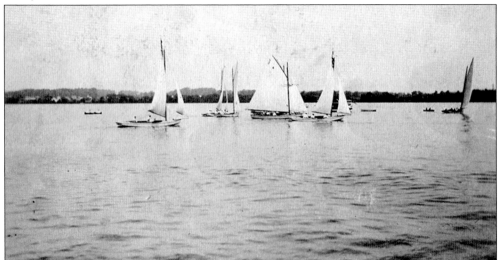

Racing started the moment two boats shared the same water, and sailing became a popular pastime. After World War II, master craftsmen Robert and Howard Lippincott operated Lippincott Boat Works at the end of little Canal Street in East Riverton. For nearly 40 years, it was one of the top builders of small racing sailboats that won multiple international championships in the Star, Lightning, and Comet classes.

Even if a person did not sail, that would not stop them from enjoying a peaceful ride in a seaworthy vessel, albeit a small craft. The Riverton Yacht Club beckoned to watercraft of all sorts. This family of seven enjoys an idyllic summer afternoon on the calm Delaware River near the yacht club around 1915.

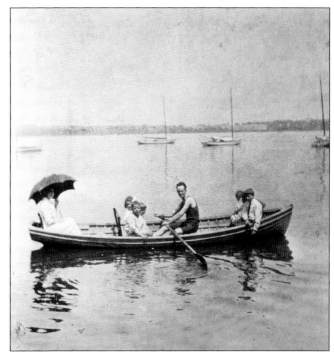

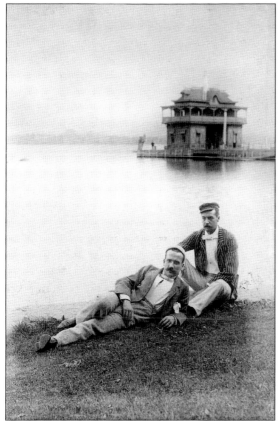

Two men relax at the river's edge sometime around 1891. For over 170 years, the Riverton founders' deliberate edict that waterfront areas remain open spaces for citizens to enjoy has been a point of local pride and is part of what makes Riverton feel like an oasis.

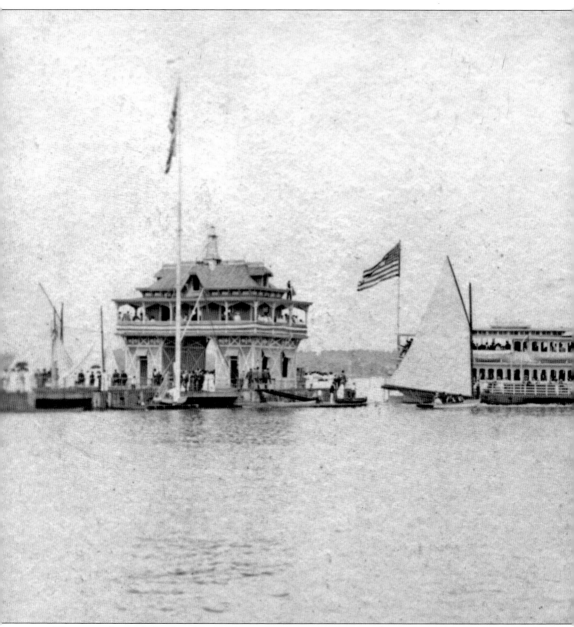

The steamboat *Columbia* departs from the Riverton pier in the early 20th century in a rare picture from the collection of Paul Schopp. Built in Wilmington in 1876, *Columbia* was one of the upper Delaware River's most elegant passenger vessels. Boasting an iron hull and an interior with more enclosed space than any other steamboat around the area at the time, it was used

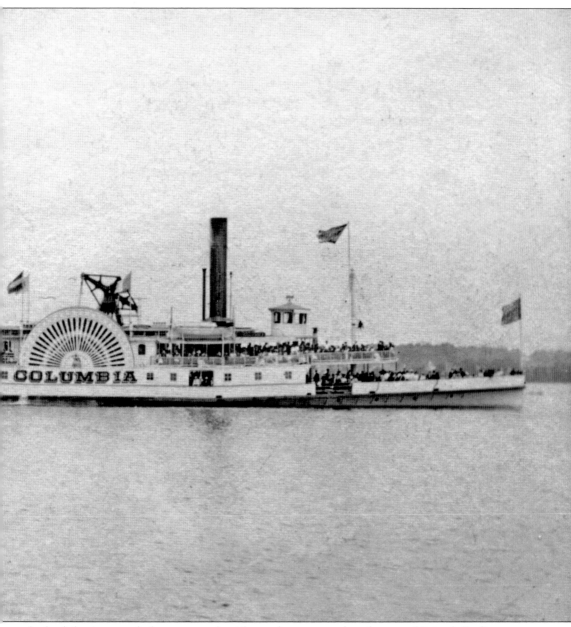

for both business and pleasure travel, with regular stops at the wharves of Bristol, Burlington, Beverly, Andalusia, Delanco, Torresdale, and Tacony, and a landing spot at Chestnut Street in Philadelphia. In warmer seasons, guests could enjoy moonlight excursion cruises with an orchestra and comfortable furniture. *Columbia* served Riverton for about 40 years.

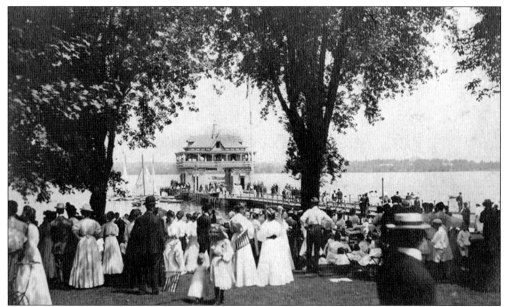

This early real-photo postcard shows a formally dressed crowd "enjoying a good time" near the Riverton Yacht Club around 1890. This throng of people was likely celebrating the Fourth of July by watching the annual regatta or listening to speeches prepared by local politicians—a tradition of that era.

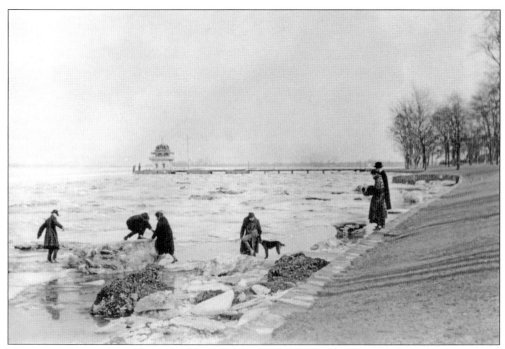

The river holds its charm for a few daring townspeople even in the winter season. In this c. 1920 image, a cold and playful group, likely in front of 303 Bank Avenue, makes a foray onto the ice for a photo opportunity.

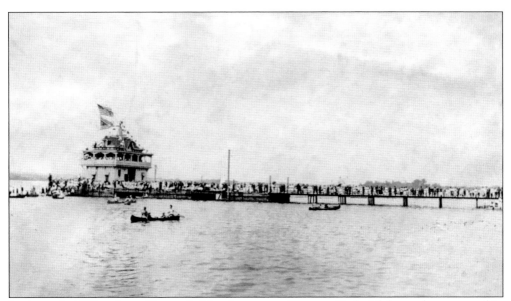

In the early 1900s, after sailing ended for the season, Riverton Yacht Club members engaged in the sport of trapshooting by firing shotguns near the end of the pier. A spring device called a trap flung saucer-shaped clay targets into the air over the water. As the shooters improved, they had to move farther away from the trap, but the building limited how far they could move. In 1921, the enterprising sportsmen moved the clubhouse to its present location closer to Main Street. Note the difference in these images from 1920 (above) and around 1948 (below).

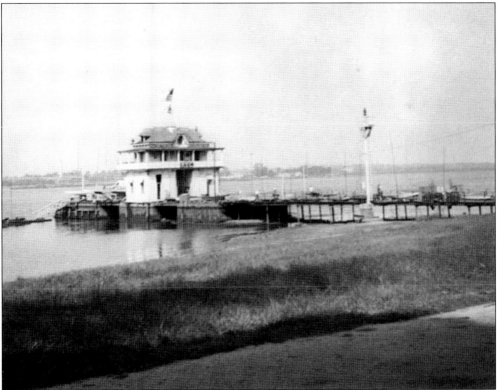

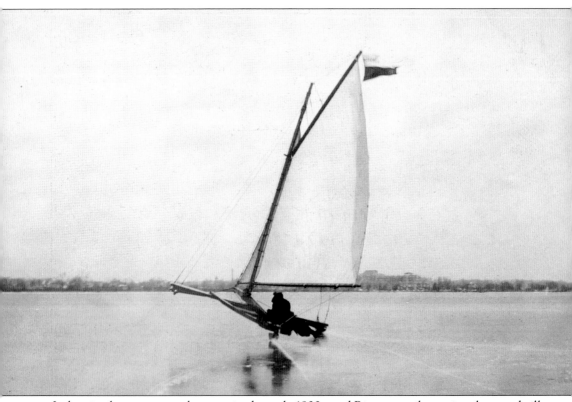

Iceboating became a popular sport in the early 1900s, and Riverton sailors enjoyed many thrills on the river when the ice was smooth or on local millponds when it was not. When winter came to the yacht club, plucky sailors like H. McIlvain Biddle fitted skids and a sail to a wooden frame and cavorted at high speed around the ice-bound Delaware.

A unique homemade watercraft appeared on the Delaware in February 1920. The propeller-driven Ice Auto featured in Philadelphia's *Evening Public Ledger* was invented by Riverton's Richard M. Hollingshead Jr., who later invented the drive-in theater. (Courtesy of the *Evening Public Ledger* archives.)

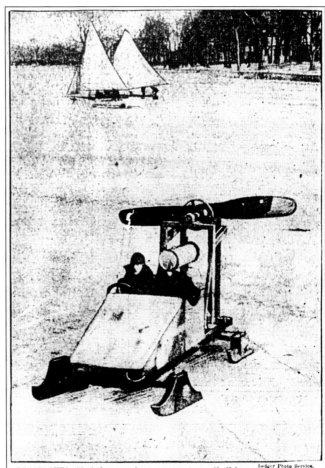

Note the skates fitted to this frame and the lines that the iceboater used to trim the sails to achieve high speeds. H. McIlvain Biddle pilots this craft. Few of these boats survived after their popularity declined, and the river did not freeze so solidly, but the removable skates are fascinating keepsakes collected by several locals.

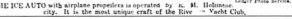

THE ICE AUTO with airplane propellers is operated by R. M. Hollinshead. city. It is the most unique craft of the River Yacht Club.

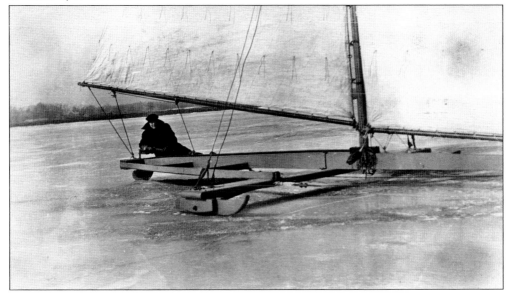

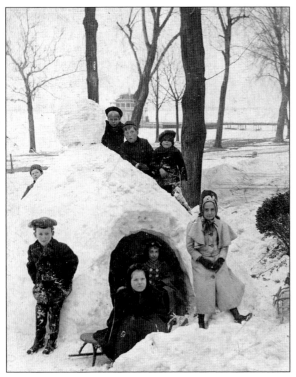

The riverbank was a magnet for fun and imagination in all seasons. Here, playmates pose by their impressive snow fort with a commanding view of the yacht club in 1896. They are, from left to right, (in front of the fort) Rex Showell, Marie Wright, Florence Sharp, and Laura White; (behind the fort) Allen Earnshaw, Walter "Sonny" Wright, Eddie P. Showell, and Eddie B. Showell.

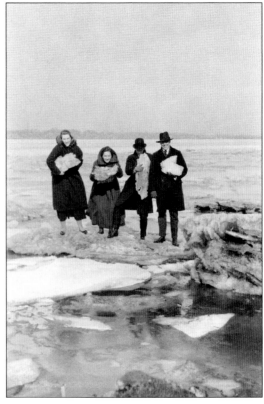

Children of all ages joined in the winter fun, as demonstrated by this group courageously posing on an "iceberg" near the yacht club around 1920. Elizabeth Miller (second from left), her father Charles (third from left), and some unidentified friends seem outrageously well-dressed for an outing on a frozen river. Charles C. Miller built the grand Georgian Revival home at 101 Lippincott Avenue in 1896 and lived there until his death almost 60 years later.

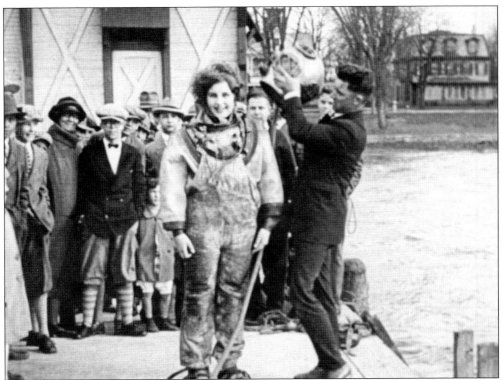

In 1926, Riverton's civic leaders commissioned a playful silent film called *The Romance of Riverton* to promote the town. In this scene filmed at the Riverton Yacht Club pier, 15-year-old Maxine Meitzner boldly models a diving suit. She lived at 618 Elm Terrace and was the granddaughter of Jacob Eisele. She was an outstanding swimmer who trained by swimming 10 miles—from the pier to Philadelphia's Arch Street Wharf—with her trainer, George Corner, in a rowboat pacing her. The home visible in the background is 405 Bank Avenue, now long gone; four maids who worked at the house 30 years earlier appear on page 22.

His acquaintances called Charles B. Durborow the "human polar bear" because he insisted on taking a morning dip before work year-round, even in winter. In the early 1900s, Durborow was a Philadelphia bank clerk who reportedly honed his muscles by tossing heavy bags of coins. The champion long-distance endurance swimmer put in over 600 miles a year. He was a founding member of the Penn Athletic Club, served as Riverton Borough clerk, and held the position of secretary and treasurer of the Riverton Yacht Club. (Courtesy of the *Evening Public Ledger* archives.)

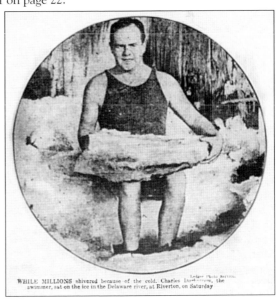

WHILE MILLIONS shivered because of the cold, Charles Durborow, the swimmer, sat on the ice in the Delaware river, at Riverton, on Saturday

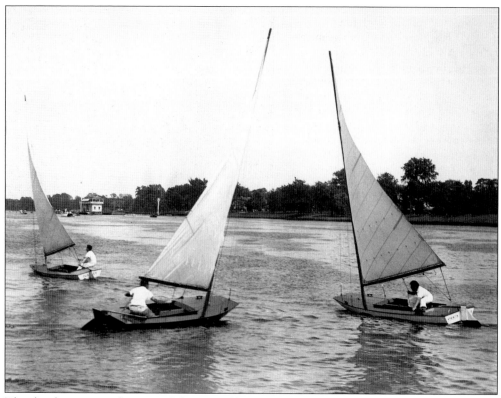

The development and racing of these nimble Duster-class boats were unique and distinctive achievements of the Riverton Yacht Club. The Duster was a very light, 14-foot craft with a flat bottom and a pram (square) bow. It was a dinghy designed to be home-built. It sported a large cat rig (no jib), and its lightweight and huge mainsail made it ideal for sailing in the light winds often found in the Riverton area during the summer.

In the 1940s and 1950s, a group of women affectionately and playfully named the Sail Bags formed a casual type of ladies' auxiliary for the yacht club. Often behind the scenes, they were invaluable for their skills in organizing social events and fundraising.

Boatbuilding culture was strong amongst Riverton Yacht Club members. In the early 1930s, the Depression changed the fortunes of many, especially the younger members of the club who could no longer afford to sail as they had in the past. An answer was conceived in 1933 by Ed Merrill, who designed a simple sailboat that could be cheaply made by amateurs with a few tools in a garage or basement—or attic, as shown in this picture of 417 Lippincott Avenue from 1947. This new class of boat was first called the Saw and Hatchet class, then promptly changed to Duster, and they soon took the community by storm.

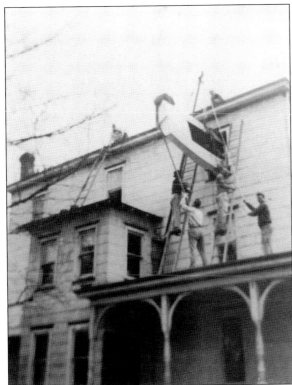

This is Ed Merrill's house at 301 Main Street, the birthplace of the Duster (although the photograph shows a new Comet-class boat exiting its home workshop). Amateurs built over 40 Dusters in the first 10 years of its existence, with 5 of them constructed down the block in Knute Hunn's cellar at 300 Howard Street. Racing of the Dusters began immediately and lasted for about 50 years at the Riverton Yacht Club. More than 400 were ultimately built at various yacht clubs. There is still an active fleet at Lake Naomi in the Poconos.

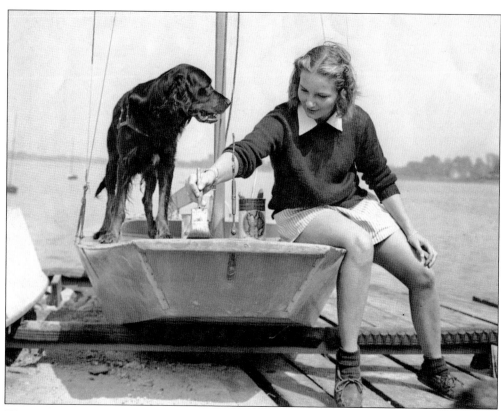

Although most sailors were men, the Duster proved popular with women sailors too, who competed on equal footing with men. Nancy Ritschard (later Hall), the great-granddaughter of Ezra Lippincott, pictured with her dog Buck, paints her own vessel on the Yacht Club pier in about 1945.

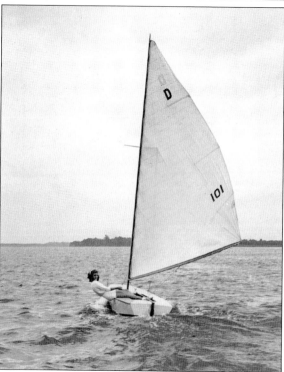

Fittingly, Riverton Yacht Club hosted the first Duster championship on Labor Day weekend in 1946 (see cover photograph). John Knight was the first national champion, with Barbara Lippincott (later Martin) as crew. Here, Lippincott sails her own Duster in a very windy competition around 1948. She proved to be a strong force in a male-dominated sport.

Some couples sailed together and separately. Ethel "Toby" Hunn stands on the Riverton Yacht Club pier with her Moth-class boat *Miss Fortune* in the summer of 1944 with her husband, Knute (who thoughtfully brought saws, a hammer, and plenty of beer). Toby placed third in the women's division in the 1946 National Moth Regatta. She and Knute also sailed many races together on their Duster.

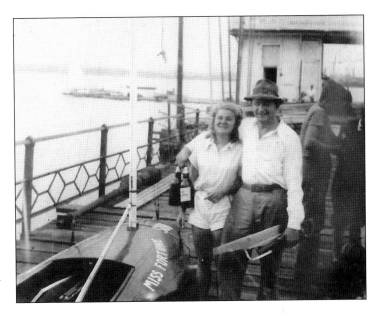

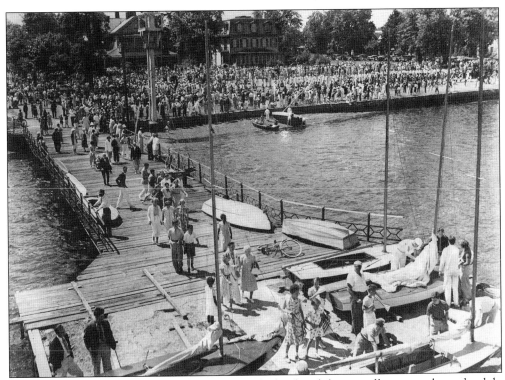

Competitive races sometimes drew massive crowds that lined the seawalls nearest the yacht club. This late morning contest was held sometime prior to 1938. The children in the foreground are holding flags, suggesting that this is probably a Fourth of July crowd after the end of the parade (which ended at the river for many decades). Two of the foreground boats are Dusters, as is the one on the beach that is tipped over for some kind of repair.

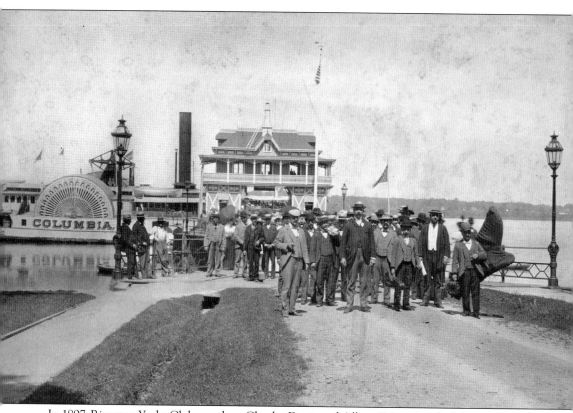

In 1897, Riverton Yacht Club members Charles Davis and Albert Briggs founded the very popular Children's Flag Parade, which is held each year on the Fourth of July. In the early years, the parade ended at the yacht club and was followed by patriotic speeches, music, yacht races, bicycle races, and fireworks on the pier. Today, the parade starts at the yacht club and proceeds to Riverton Park, where larger crowds can participate in events for revelers of all ages.

Three

RIVERTON'S FOURTH OF JULY

Riverton's Fourth of July celebration has been—and still is—one of the town's most popular events. The Children's Flag Parade welcomes all children to participate and lead the march down Main Street to the Riverton Yacht Club on Bank Avenue. Children of all ages lead this procession in front of 101 Main Street in the late 1920s. Once the parade ended at Bank Avenue, it was traditional for the crowd to sing patriotic songs led by a band. The athletic races, games, and contests that followed made the day's festivities even more exciting.

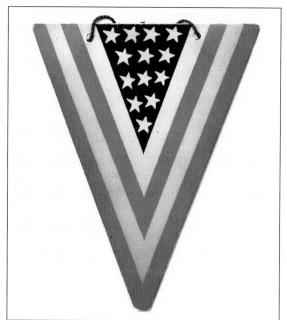

The one-of-a-kind burgee of the Riverton Yacht Club, which has a fascinating history of its own, graces the cover of this program from July 4, 1914. An inside page shows the typical lineup of events and races that made up the day's festivities.

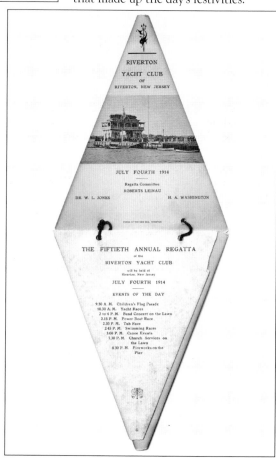

RIVERTON
YACHT CLUB
OF
RIVERTON, NEW JERSEY

JULY FOURTH 1914

Regatta Committee
ROBERTS LEINAU

DR. W. L. JONES H. A. WASHINGTON

THE FIFTIETH ANNUAL REGATTA
of the
RIVERTON YACHT CLUB
will be held at
Riverton, New Jersey

JULY FOURTH 1914

EVENTS OF THE DAY

9.30 A. M. Children's Flag Parade
10.30 A.M. Yacht Races
2 to 4 P. M. Band Concert on the Lawn
2.15 P. M. Power Boat Race
2.30 P. M. Tub Race
2.45 P. M. Swimming Races
3.00 P. M. Canoe Events
7.30 P. M. Church Services on
the Lawn
8.30 P. M. Fireworks on the
Pier

Dedicated on July 4, 1894, the Riverton Athletic Association bicycle track stood adjacent to Little Broad Street between Thomas and Lippincott Avenues. The quarter-mile track featured five-and-a-half-foot-high banked turns, a clubhouse, bleachers, grandstand seating for 3,000, and arc lights to illuminate night races. In 1895, the *Philadelphia Inquirer* proclaimed it "one of the finest quarter-mile tracks in the world." When the association could no longer sustain the track, the land was developed into building lots.

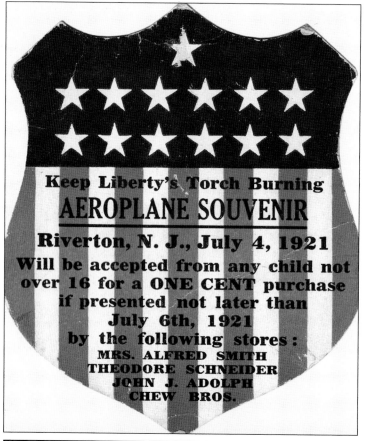

Keep Liberty's Torch Burning
AEROPLANE SOUVENIR
Riverton, N. J., July 4, 1921
Will be accepted from any child not over 16 for a ONE CENT purchase if presented not later than July 6th, 1921 by the following stores:
MRS. ALFRED SMITH
THEODORE SCHNEIDER
JOHN J. ADOLPH
CHEW BROS.

On July 4, 1921, a plane soared over the Riverton Yacht Club and dropped 575 "Aeroplane Souvenir" tickets that were shaped like patriotic shields and good for between 1¢ and 25¢ in goods from local stores, and the children on the banks scurried to collect them. Civic boosters Charles A. Wright and Richard M. Hollingshead Sr. hired the plane and funded the event. The biplane dropping the souvenir tickets set off a mad scramble on the riverbank, as shown below.

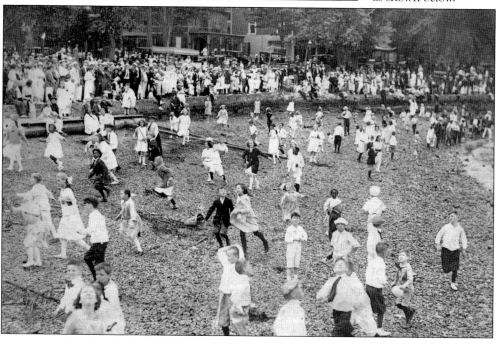

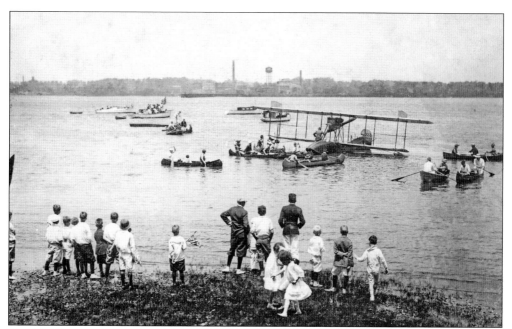

Frank Mills owned and piloted the Curtiss hydroplane that promoted the famous 1921 Fourth of July event discussed on the previous page. The plane took off and landed on the water near the Riverton Yacht Club. Mills also offered exhibition flights and gave sky rides for a fee.

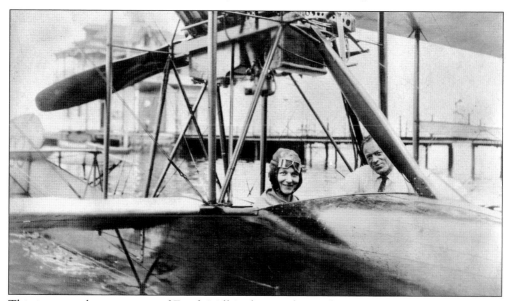

This is a rare close-up image of Frank Mills's plane and one of its passengers posing with Mills. The Riverton Yacht Club is clearly visible in the background.

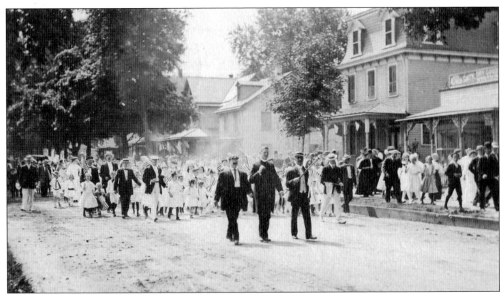

In 1897, a long-standing Fourth of July ritual was born—having the parade marshal carry a cane. The first marshal's baton was a gift from Og Mattis's grandfather, Louis Corner, who had come from England to Riverton in 1863. After a visit to Switzerland in 1897, he brought back two Alpine sticks and presented them to the town for the purpose of recording the number of children in the annual parade year by year. Silver bands engraved with that number alongside the mayor's name have been attached to the cane after every parade since.

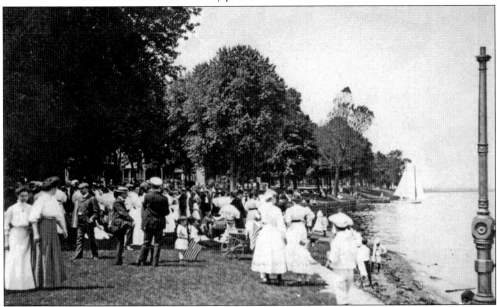

This would have been a typical scene after the Children's Flag Parade as crowds gathered along the banks to watch races, hear concerts, and listen to political speeches. The evening would have included fireworks set off from the end of the Riverton Yacht Club pier over the river—a beloved but terrifying tradition that lasted through 1966. It ended after the crowd size reached 10,000 and there were several incidents, including half of the fireworks exploding at once in 1965, which blew off part of the yacht club roof.

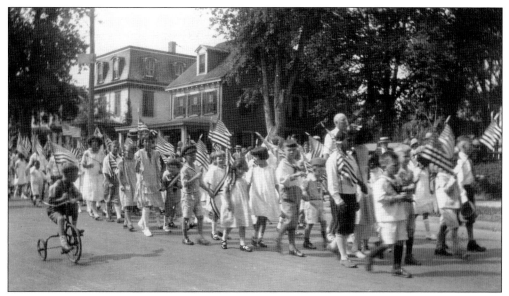

The Children's Flag Parade grew each year to include marching bands and troops celebrating their return from war. In a very moving ceremony to mark the end of World War I, the town's governing body presented each returning soldier, including veteran nurse Amanda Faunce, with a gold ring to celebrate their safe return.

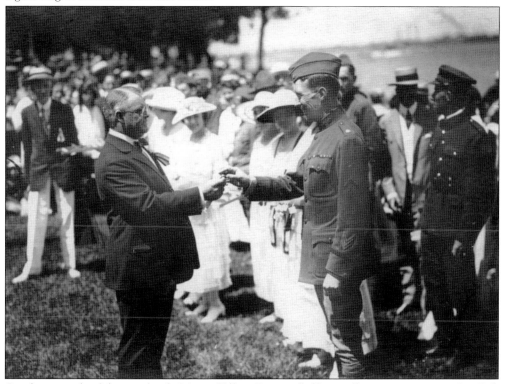

On the grounds of the riverbank, Mayor Killam Bennet (left) proudly presents a ring to Lt. Col. Franklin D'Olier on July 5, 1920. D'Olier served as the first national commander of the American Legion from 1919 to 1920.

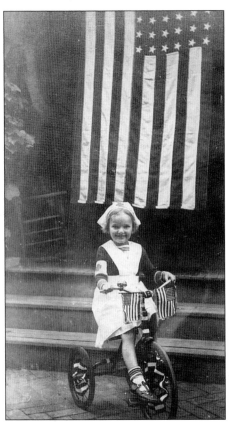

As a little girl in 1933, Nancy Ritschard (later Hall) dressed up as a nurse and eagerly waited on her new tricycle to join the other youngsters in the Children's Flag Parade. As the great-granddaughter of Ezra Lippincott, Nancy has deep family roots with a strong and proud heritage.

Ann "Bay" Ruff and her bike partner Ted Hunn rode a bicycle built for two in the Fourth of July parade in 1938. Ruff was a central figure in community social circles as well as a noted author and artist who wrote and illustrated a rich book about life in Riverton called *Ruff Copy*. Hunn was quite a skilled sailor.

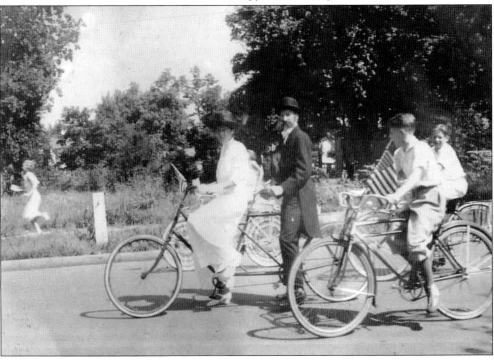

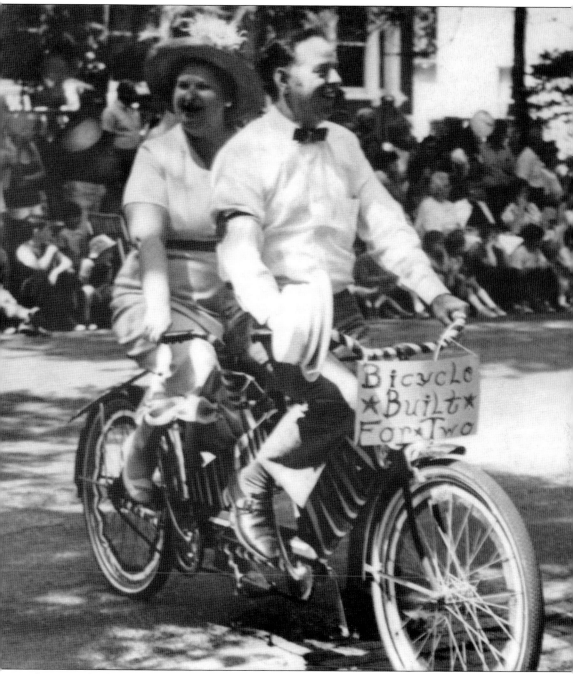

The joy of the day is obvious on the faces of Paul and Cathy Daly as they ride their bicycle built for two through town, probably during the 1976 bicentennial celebration. The Dalys hosted a Fourth of July picnic at their home that was a tradition for over 60 consecutive years. Many citizens joined in the fun on the 4th by dressing in Victorian attire and joining the parade on foot or bike.

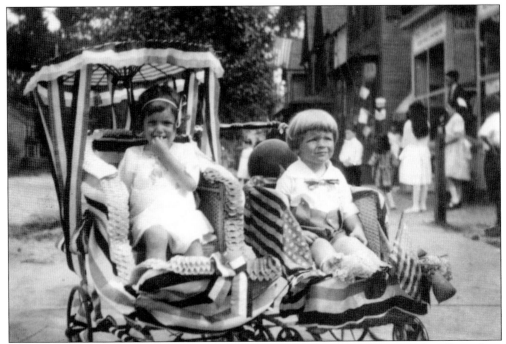

Above, Elsie Showell (left) and her cousin John wait on a Howard Street sidewalk in their patriotically embellished perambulators for the start of a Children's Flag Parade in the early 1920s. Below, more than 90 years after the above photograph was taken, Elsie Showell Waters reigned as the 2013 parade marshal down that same route in her beloved hometown. She and other remarkable women have played extraordinary roles in the history of Riverton.

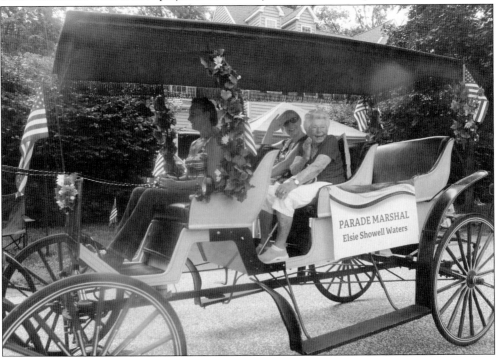

Four

Notable Women
of Riverton

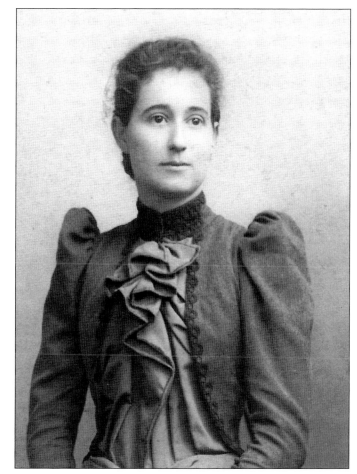

The daughter of a devout Quaker and Ezra Lippincott, Helen Lippincott served a prominent role in the women's rights movement as a nationally renowned suffragist in the early 20th century. A charter member of the Porch Club, she founded its Suffrage Section in 1904; served as treasurer of the New Jersey Women's Suffrage Association; was a delegate, life member, and member of the executive committee of the National Women's Suffrage Association; and was a delegate to the Congress of International Women's Suffrage Alliance in Geneva in 1920.

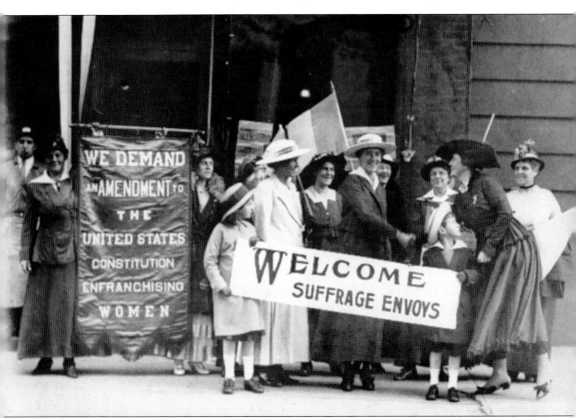

The 1913 Suffrage March from New York City to Washington, DC, was the first large march on Washington for political purposes. Suffragists Alice Paul and Lucy Burns organized the procession for the National American Woman Suffrage Association (NAWSA), in which several Riverton women held leadership roles. Helen Lippincott took part in the Washington demonstration where petitions were presented to the Senate asking for the immediate submission of the Federal Suffrage Amendment. The ratification of the 19th Amendment on August 18, 1920, finally guaranteed all women the right to vote in the United States. (Courtesy of the Library of Congress.)

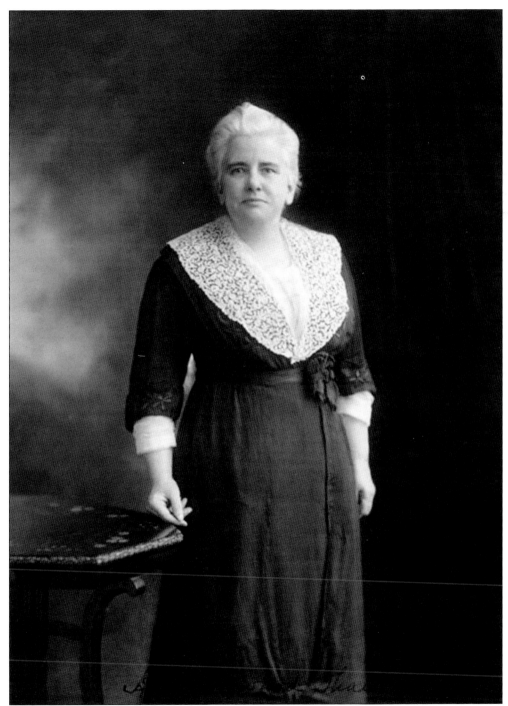

In February 1907, a Porch Club Suffrage Section meeting attended by over 100 people was held at Helen Lippincott's home at 107 Lippincott Avenue. Rev. Anna Shaw (pictured), president of the National Woman Suffrage Association from 1904 to 1915, was the guest of honor. Along with Alice Paul, Shaw helped inspire local action in the efforts to promote voting rights for women. (Courtesy of the Library of Congress.)

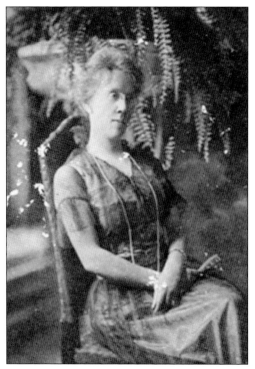

In the early 1900s, Mary Ann Mecray Marcy of Riverton played an enormous role in the lives of children throughout the state of New Jersey and beyond. She was elected the second president of the Congress of Mothers in Trenton; this was a nationally focused campaign to improve the health and well-being of children throughout the nation. Marcy and other New Jersey delegates helped lead political campaigns to secure equal education, organized mothers' support groups, and established nutritional programs. Her investment in the country's children yielded immeasurable dividends. She and her husband, Dr. Alexander Marcy, lived at 406 Main Street (shown below as it stands today).

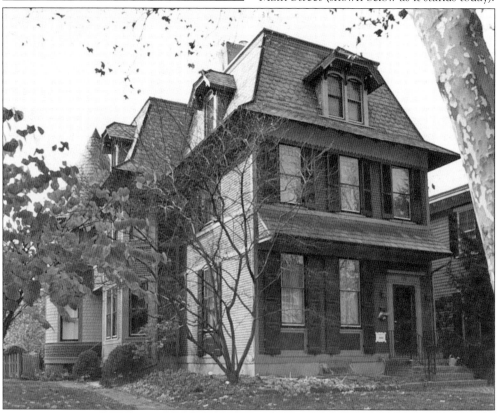

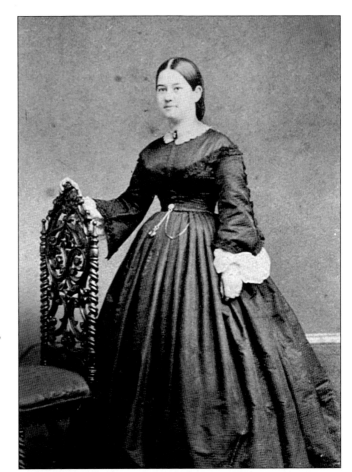

Anna Sutton Lippincott lived at 303 Bank Avenue with her husband, Ezra Lippincott. Each played a prominent role in society. As a Quaker, Anna was not given to passing high fashion, but the mid-1800s dress she is wearing the picture at right shows her exquisite taste and refinement. Below, in 1887, Ezra (at left, in the hat) sits on his porch with Anna to his left and some of their family members surrounding them.

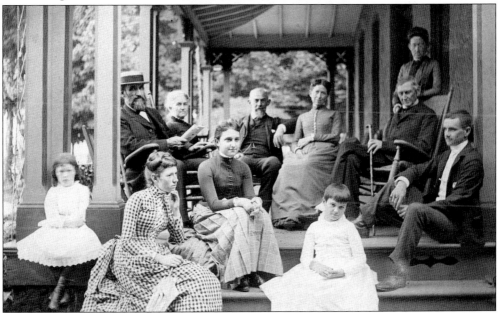

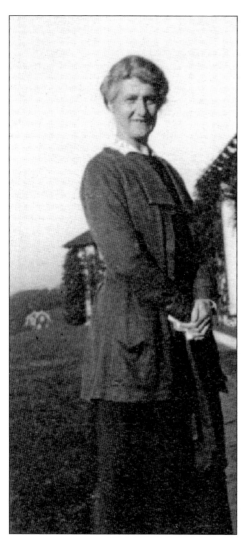

During the 1890s, when photography as a fine art was just emerging, a pioneering young woman from Riverton achieved a reputation as a successful advertising photographer whose work commanded high prices. Bertha Lothrop (pictured at left) exhibited children's portraits at the Photographic Society of Philadelphia and published a technical pamphlet on indoor photography. Her father, David Lothrop, had been a prolific studio photographer for decades. She built herself a comfortable studio behind her family home at 401 Main Street. In 1905, Bertha married Frederick W. Radell in Riverton, and by 1910, they had moved to Abington Township. She appeared as an exhibitor at a photographers' convention in Philadelphia in 1912.

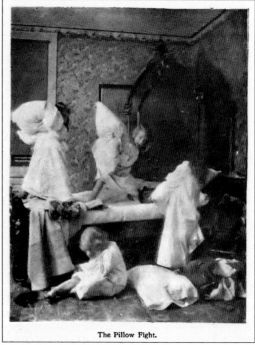

The Pillow Fight.

"Uncle George" Senat was a popular figure in Riverton. For 35 years, he lived alone in a house at 306 Main Street (above). Riverton's founders had built the cottage on speculation in 1853 based on a design (below) in A.J. Downing's 1850 pattern book *Country Houses*. After Senat died in 1898, his niece Mary Senat inherited the cottage; in 1907, she sold it to Sarah Morris Perot Ogden, who then donated it—in memory of her late husband, Edward—to the fledgling Riverton Free Library Association for use as its permanent home. It still serves as the library to this day.

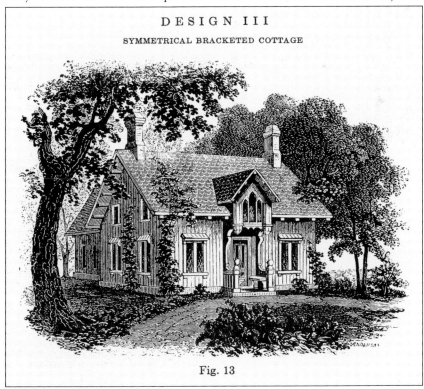

DESIGN III

SYMMETRICAL BRACKETED COTTAGE

Fig. 13

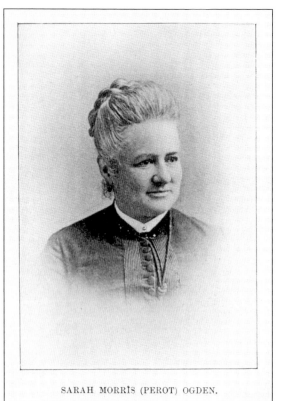

SARAH MORRIS (PEROT) OGDEN.

Sarah Morris Perot Ogden was a woman of remarkable achievement who served society immensely through her numerous leadership roles in social and civic organizations. Whether in her capacity as a Civil War hospital volunteer or managing a sewing school for needy women, as a member of several social clubs, in presiding over numerous philanthropic organizations and serving on the boards of several charitable organizations, in raising money to build a clubhouse for enlisted men, or serving as the second president of the Porch Club, she worked throughout her life to improve the human condition. After her death, Georgine N.W. Shillard-Smith said, "she has bequeathed an ideal which all who knew her will never cease to revere."

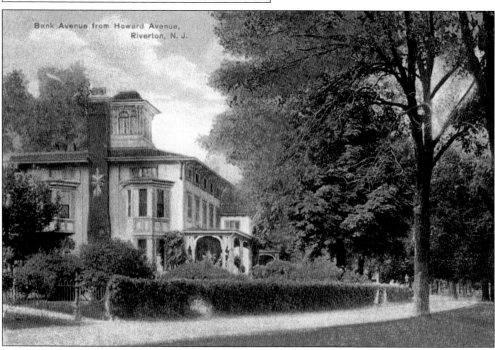

This early picture postcard shows what 503 Bank Avenue looked like when Sarah Ogden and her husband, Edward, lived in the house. It was formerly the home of Riverton founder Caleb Clothier.

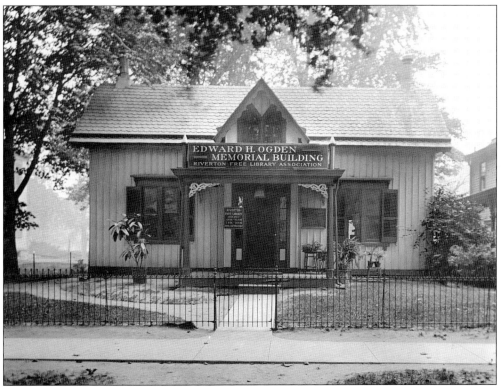

This is 306 Main Street after Sarah Morris Perot Ogden donated it to serve as the town library in 1908. Before this, the library was housed for nine years in the Reading Room in the Parish House of Riverton's Christ Episcopal Church.

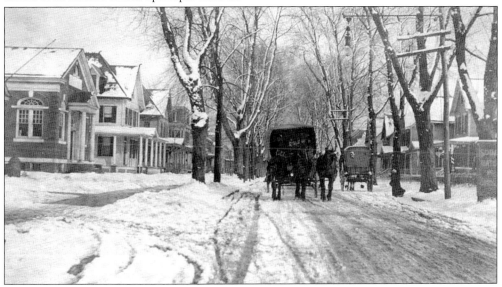

Winter has arrived at Riverton in this c. 1907 image featuring a carriage ride on Main Street. The photograph reveals the great development of homes and businesses taking place on Main Street south of Broad Street. The first building on the left (611 Main Street) served as the first location of Cinnaminson National Bank.

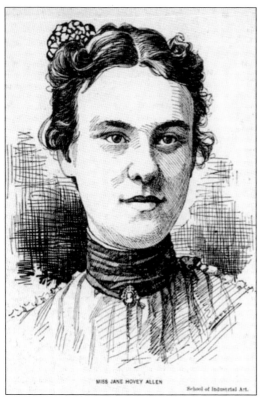

MISS JANE HOVEY ALLEN

School of Industrial Art.

Jane Hovey Allen Boyer distinguished herself as a talented, award-winning illustrator and painter who lived at 304 Eighth Street in a home she and her husband built when they married in 1902. Boyer attended the Philadelphia Museum of Art and won several prizes there. She illustrated the popular World War I–era Mary Frances adventure series of books written by Jane Eayre Fryer, which used whimsical stories to teach young girls to sew, cook, garden, and keep house.

The image at right is from the *Mary Frances Sewing Book; Or, Adventures Among the Thimble People* by Jane Eayre Fryer; it was published in 1913 and illustrated by Jane Allen Boyer. The Mary Frances series of books continue to be prized collectibles due in part to their charming illustrations by Boyer. Her considerable accomplishments as a member of Christ Church, the Porch Club, the Red Cross, the Cinnaminson Home Board of Managers, and the Welfare Association of Riverton and Cinnaminson certainly helped improve the well-being of the borough's citizens.

Let me see. Said Fairy Lady

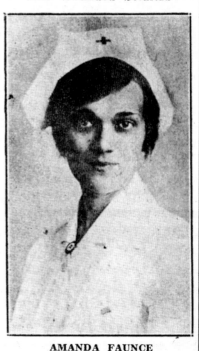

AMANDA FAUNCE

Riverton had four outstanding women nurses who served in World War I: Helen "Elsie" Biddle, Edith Coale, Amanda Faunce, and Edith Holvick. Two served at the front in France. Faunce (left) lived with her large family at 502 Howard Street. Upon her return, the town gave her a gold ring because she had served in an Army hospital. Biddle (below) worked with refugee civilians whose homes and villages were destroyed by the fighting. She was the daughter of Charles Miller Biddle and lived at or near Bank and Lippincott Avenues for her entire life.

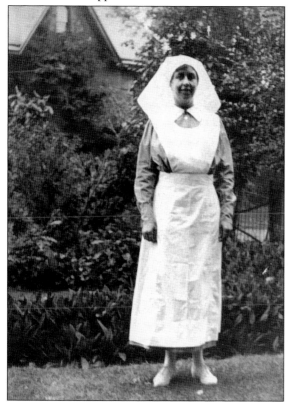

This is what it was like to be wealthy in Riverton around 1887, taking a drive on Bank Avenue. Nannie Heiskell Myers Fitler (at left in the coach) and her mother, Margaret A. Myers, ride in style with stunning horses, an impeccably liveried coachman, and a perfect Victoria-style coach. Nannie was married to Edwin H. Fitler Jr., whose father was a popular mayor of Philadelphia and

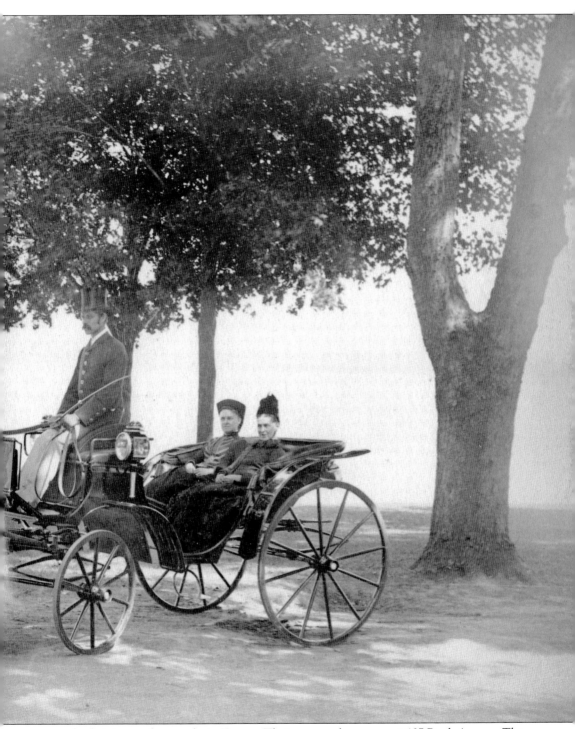

owner of a thriving cordage works in Tacony. Their summer home was at 407 Bank Avenue. The history of the Fitler family is interwoven with those of other notable Riverton families throughout many decades.

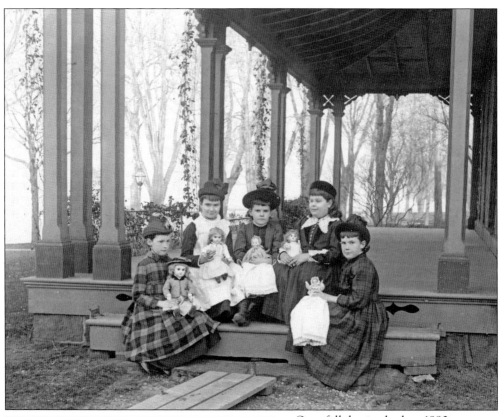

On a fall day in the late 1880s, five preteen Quaker cousins pose with their dressed-up dolls on the porch of 303 Bank Avenue. They are, from left to right, Edith Coale, Alice Lippincott, Mary Lippincott, Hannah "Nannie" Biddle, and Anna Lippincott. Little ladies of that era and class were taught the gentle arts for becoming good wives and mothers.

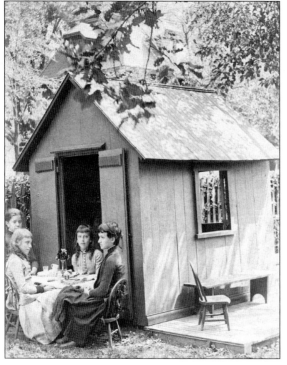

Sociable gatherings in Riverton were and still are a popular pastime for citizens of all ages. From left to right, cousins Elsie Biddle, the Frishmuth twins (Anna and Mary), and Bertha Lippincott enjoy a special teatime together in the late 1880s at their child-sized playhouse that may have been a repurposed garden shed.

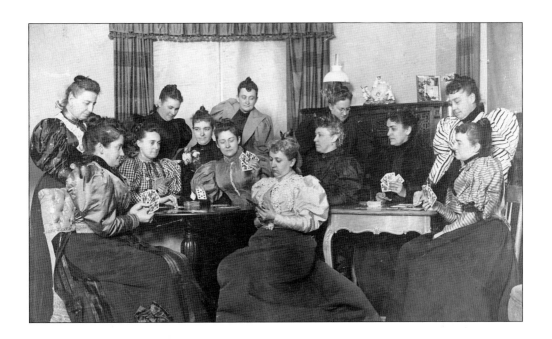

According to the *Philadelphia Inquirer* society pages in the late 1890s, Riverton ladies hosted royal bezique games in their homes as well as at the Lyceum, the town assembly and social building located at 403 Fourth Street. The card game of bezique is a trick-taking card game for two played with a double-pack of 64 cards, including the seven to ace only in each suit. Ladies traveled from Philadelphia to join the game, and among those noted as hostesses here were Nannie Fitler, Hannah Frishmuth, and sisters Julia and Lizzie Cook.

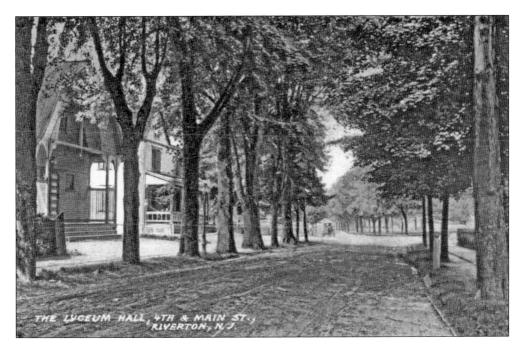

THE LYCEUM HALL, 4TH & MAIN ST., RIVERTON, N.J.

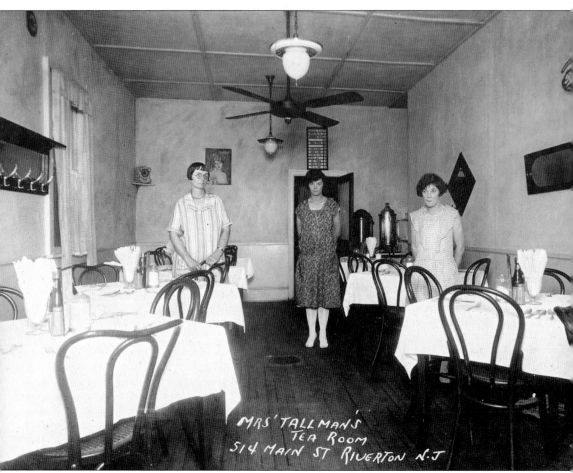

Women had to be particularly creative to cope with ill fortune. Florence Tallman (left) is shown at her Tea Room located at 514 Main Street around 1929. Divorced and raising three young children, she rented the building for $20 per month, and the family lived upstairs. Menu items included breakfast and lunch specials as well as some pies, puddings, tea, and coffee.

Helen Williams grew up in East Riverton and became the most photographed African American fashion model of the 1960s. She studied art after she retired from modeling and has completed dozens of paintings. Right after she graduated from Palmyra High School, a New York fashion studio recruited her; she became a fashion stylist and then a model for *Ebony*, *Jet*, and *Tan* magazines. A move to Paris catapulted her to high-fashion status and celebrity, giving her recognition that improved her modeling career when she returned to the United States in the late 1970s and made Riverton her permanent home. She is pictured below as a child (at left) with her sister Marietta and their mother, Helen.

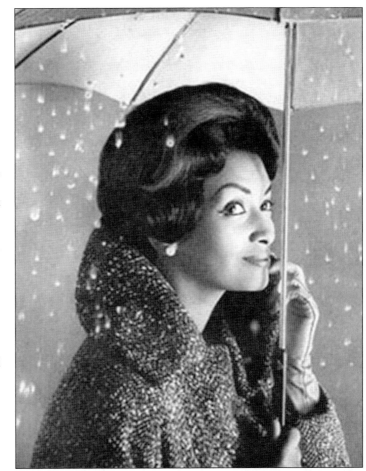

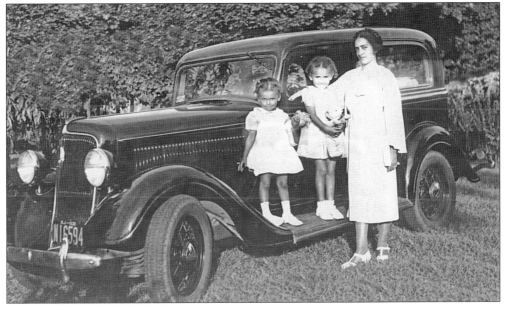

Anne "Bay" Knight Ruff was the youngest of seven children born to Gertrude and Robert Knight in 1920. The local artist, author, and humanitarian taught many Riverton children to swim in the pool at her home at 4 Thomas Avenue. Bay and her granddaughter Marcy are pictured above near a window in her eclectic home. Her marvelous and colorful interpretations of historic Riverton scenes on salvaged wood, handmade quilts, pots, and sculptures have delighted many.

Among the many achievements of the women of Riverton, those of Betty B. Hahle have especially helped bring the history of Riverton to life thanks to her collecting of images, letters, and memorabilia and her long-running column in the *Gaslight News*. Her unique collection captures and pieces together the often complex history of Riverton. Much of the local knowledge of Riverton's history is owed to her extensive research.

Councilman Bruce Gunn (at left) looks on as Betty B. Hahle receives congratulations on her appointment as the first borough historian in 1995. Hahle told a correspondent from the *Philadelphia Inquirer* that tracking down the borough's history was like "doing a puzzle . . . there's always another piece."

F. Gutekunst *Philadelphia*

A prominent suffragist, Mary VanMeter Grice offered a model for the impact that women could make on history. She lived at 204 Broad Street (at the corner of Lippincott Avenue) for over 20 years. Locally, she was the first woman elected to a school board in Burlington County, founder and first president of the New Jersey State Congress of Mothers (the forerunner of the Parent Teacher Association [PTA]), and a founding member and first president of the Porch Club. After moving to Philadelphia in 1903, she continued her activism in educational, suffrage, and social causes, going on to serve on Alice Paul's advisory council of the Congressional Union for Woman Suffrage. Grice famously said, "The ballot is the best weapon that Democracy has yet produced for the protection of the house. Can we doubt in what cause woman will use it?"

Five

CULTURE AND COMMUNITY

A pastime began in a small town when eight young women met on porches each week for a reading circle and were soon joined by others. In 1895, they organized more formally and became known as the Porch Club of Riverton. At that time, membership was limited to 25 people, and for the next nine years, the club met in the home of Sarah Ogden at 503 Bank Avenue. After renting space in different locations around town, the club purchased land at Fourth and Howard Streets and built a clubhouse (pictured) in 1909. The Porch Club stands for community service above all things, and it enjoys a rich history as a Riverton icon and a "center of thought and action for the women of Riverton" as well as for others in the community; this was the club's initial stated purpose when it started so many years ago.

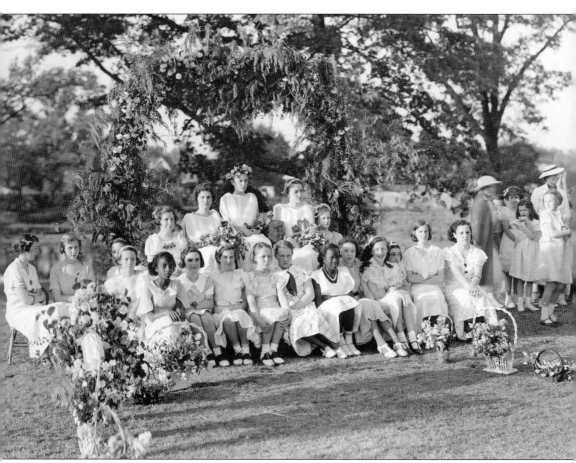

Members of the Porch Club would lead the way for many important institutions, including the Parent Teacher Association (PTA). May Day in Riverton was an important and exciting event sponsored by the local Mother's Circle (a forerunner of the PTA). This grassroots organization fanned out into a larger nationally recognized group that some early Riverton women played important roles in the establishment of. This c. 1936 photograph features the May Queen and her court beautifully posed. May Day was considered a highlight of the school year and included younger children's plays, dances, and reenactments of local historical events. The event often drew enough attention to be included in local newspaper accounts.

Cheryl Johnson dressed up as an Irish lass to perform in the dances and pageants for Riverton's May Day festivities in 1955. There was a part for everyone in the May Day celebrations.

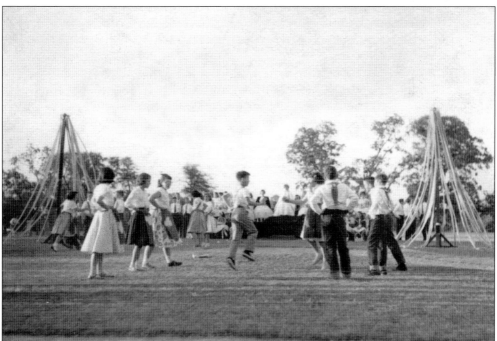

Pictured here is a typical May Day celebration, which included a traditional maypole dance held in Riverton Memorial Park. This picture dates to the mid-1950s.

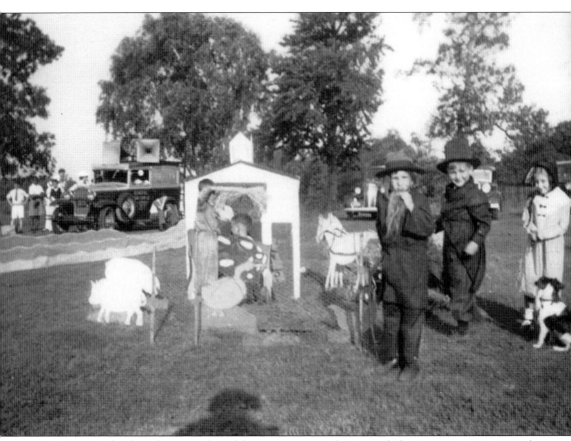

Riverton School teachers staged an elaborate pageant at the Annual Play Day on May 21, 1936, that included costumed children taking part in reenactments of local historical events. The children performed skits about the founding of the town in 1851, steamboat and rail transportation, shad fishing, and the establishment of the school, library, churches, Riverton Yacht Club, and Porch Club.

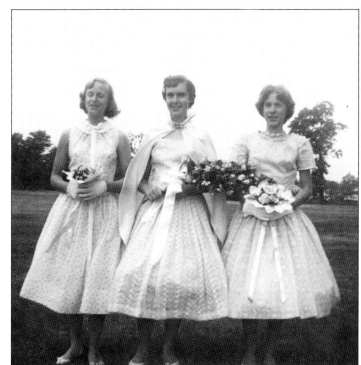

In the image at right, the eighth-grade May Queen stands with two members of her court during the traditional pageant in 1957 at Riverton Memorial Park. Below, Jimmy Johnson (right) dances with his partner, with both of them dressed in fancy costumes.

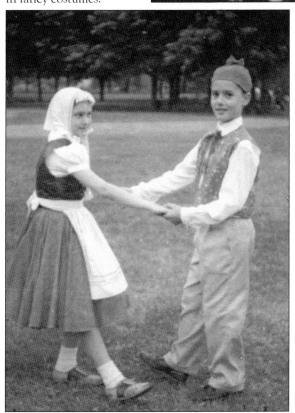

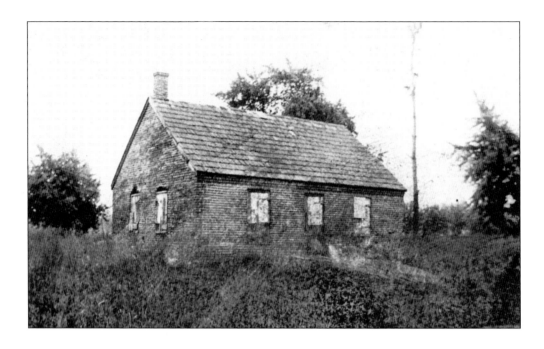

There were at least three school buildings before the main building was erected in 1910. The first Riverton Public School was built in 1822, long before there was a Riverton. It was a brick one-room schoolhouse located near where today's Elm Terrace intersects with Little Broad Street. It was replaced by a frame building at Fourth and Howard Streets and another, larger building in front of it in 1892. The first two schools did not have central heat or indoor sanitation facilities. The below image shows the current building between 1910 and 1920.

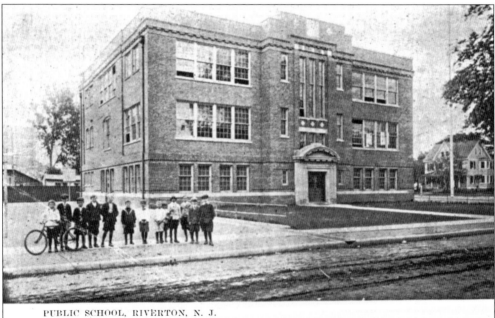

PUBLIC SCHOOL, RIVERTON, N. J.

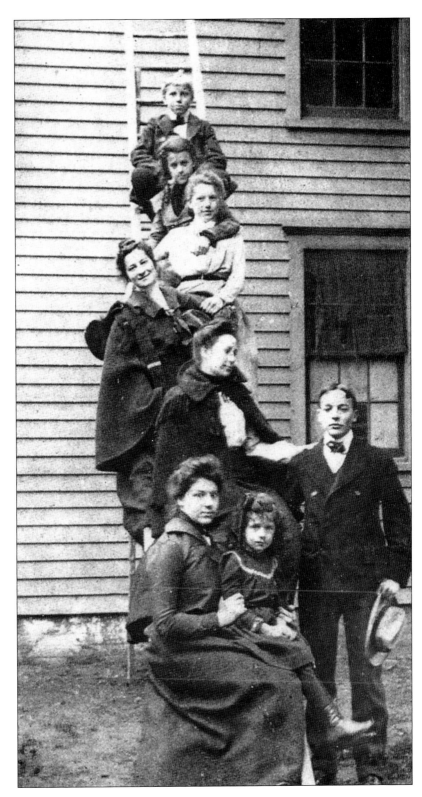

Members of the Wright clan pose on a ladder leaning against Riverton's first big school, which was built in 1892.

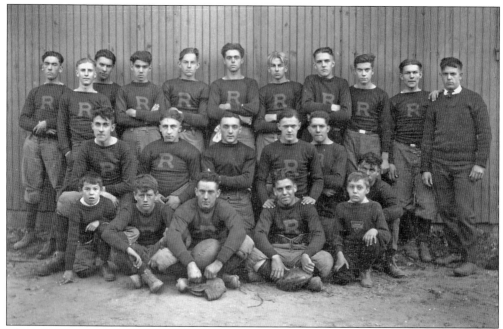

The *New York Times* observed in 1895 that Riverton Athletic Association had a "reputation in the world of sports that is second to none." From 1865 until about 1942, the association's amateur athletes competed in numerous regional sports competitions, including bicycle racing, yacht racing, baseball, cricket, basketball, and football.

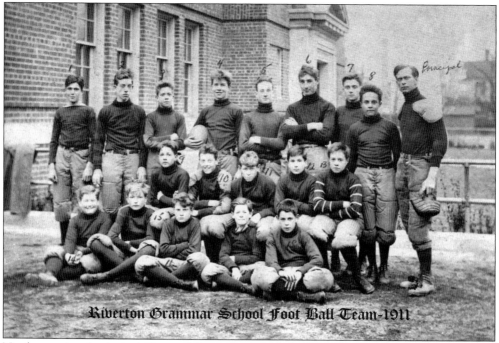

Newly appointed principal Sigmund Leymel coached this Riverton Grammar School football team in 1911. Presumably, this is one of the 25 football pictures for which the *New Era* reported a school expense of $11 on December 22, 1911.

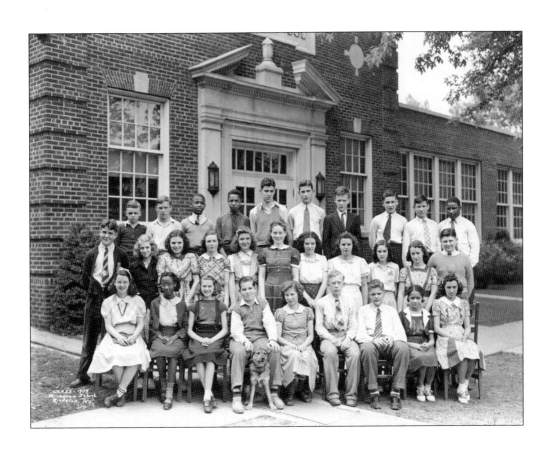

Riverton Public School educates students from kindergarten through eighth grade, and the sending district for the high school is Palmyra. Above, the eighth-grade class of 1939 poses in front of the school at Fifth and Howard Streets. One boy in the first row brought his dog. Below, members of the Palmyra High School class of 1935 are dressed to the nines in this photograph taken in Washington, DC, around 1935. Several successive images had to be "stitched" together to produce panoramas like this, which allowed one prankster, John Geiss, time to run from one end of the group to the other so that he appears twice in the picture.

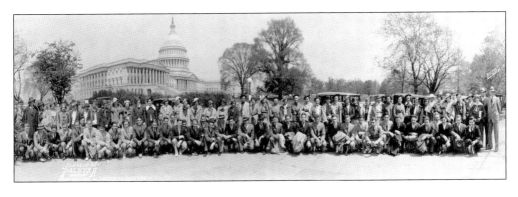

Children of Riverton knew how to enjoy the outdoors. With Dreer's Nursery as a backdrop, Young Giles Knight (at left, on a tricycle), Buddy Brown (center), and Jacob Strohlein are pictured here, possibly in front of 418 Fulton Street, where Strohlein lived.

A day in the life of an early Riverton child during the 1950s was probably idyllic given the small community and its wide range of areas to play. These four buckaroos are, from left to right, Bruce Gunn (future mayor of Riverton), Bob Waters, Jeff Cole, and John Waters.

For kids growing up in 1926, the entirety of Riverton could serve as their playground. These barefoot adventurers may be setting up a wagon/scooter/bike race of sorts down at what was then known as "Irish Row" on Cinnaminson Street south of the railroad. From left to right are three McDermott brothers—Bill, Paul, and Carl—followed by Les and Joe Yearly and Ducky Spear.

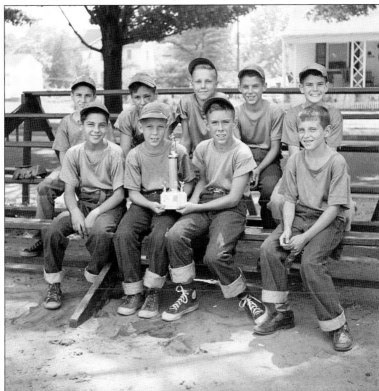

The boys of the 1954 Riverton Little League baseball team proudly display their trophy at Riverton Memorial Park.

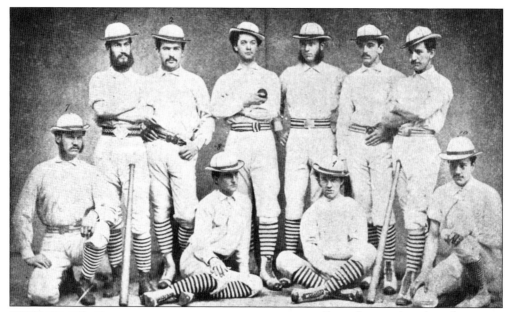

From the town's earliest days, Riverton folks enjoyed sports such as tennis, golf, baseball, football, and even cricket. The Riverton Ball Club was organized in 1865, a respectable two months after the end of the Civil War. *Sporting Life* magazine said of the 1872 baseball team that "this club made the game it is today." The Riverton Nine were so highly regarded that Henry Chadwick, the Father of Baseball, recalled an 1890 game in which they played as one of the best he had ever seen. A June 4, 1895, *New York Times* article stated: "During the old days of baseball, perhaps no amateur club in the country was so well known as the Rivertons." As local participation in the game diminished and the bicycling craze grew, the cycling club leased fields from the team in 1894.

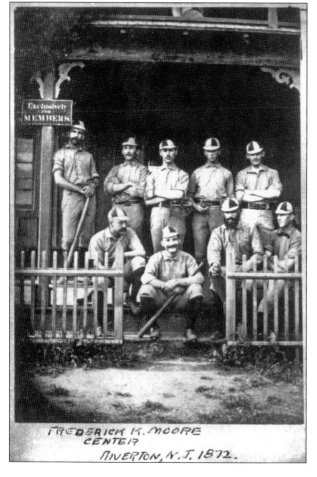

FREDERICK K. MOORE
CENTER
RIVERTON, N.J. 1872.

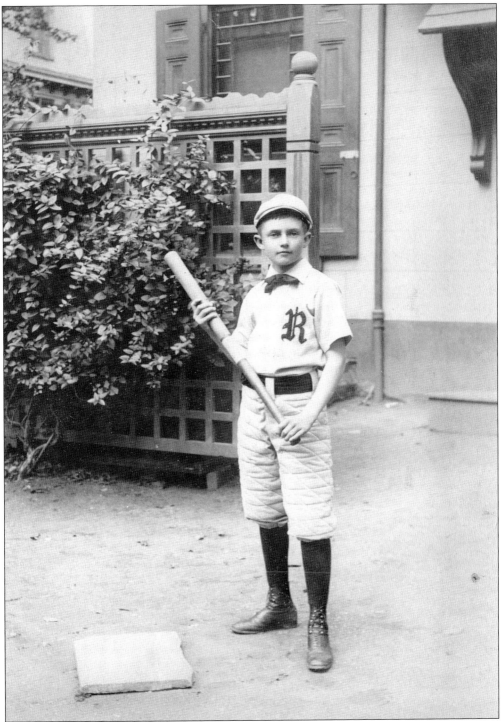

Riverton boys played organized baseball early in the popularity of the sport. N. Myers Fitler is posing proudly in his uniform behind his house at 407 Bank Avenue in the late 1880s. He grew up to own a riverbank house (at 109 Bank Avenue) with his wife, author Mary Biddle Fitler.

Founded in 1878, the famous Riverton Gun Club held trapshooting contests by releasing and shooting live pigeons. The members—all men—included most of the leading citizens of Riverton. The club bought a 30-acre tract in East Riverton, converted a farmhouse into a well-appointed clubhouse, and built two shooting boxes. Members paid entry fees to compete for prizes like bronze and silver trophies, a handsome clock, cut glass, a live monkey, and cash. Thomas Dando won a high-stakes match in March 1896 that required a $100 entry fee and awarded $1,300 as the first-place prize. The shooters killed 485 pigeons in this one match. Annie Oakley, the star of *Buffalo Bill's Wild West Show,* refereed a contest between a New York marksman and Riverton's crack shot, Charles Macalester. Even after New Jersey outlawed live pigeon shoots in 1904, the men vowed to fight it. After being indicted and fined and exhausting their appeals, the sportsmen had to admit defeat in 1906.

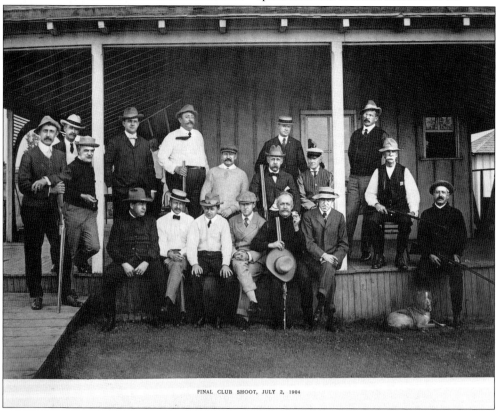

FINAL CLUB SHOOT, JULY 2, 1904

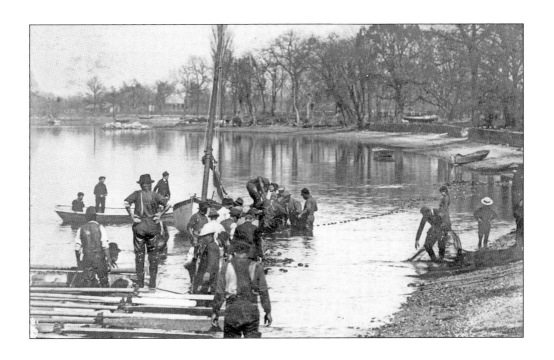

The Delaware River has long been a rich source of fish, especially the huge schools of shad that ran during April and May every year. Deeds gave people explicit rights to fish, and fishermen worked long hours stretching enormous nets into the river. The photographer of the c. 1910 pictured above was looking upriver from the foot of Howard Street during the shad run.

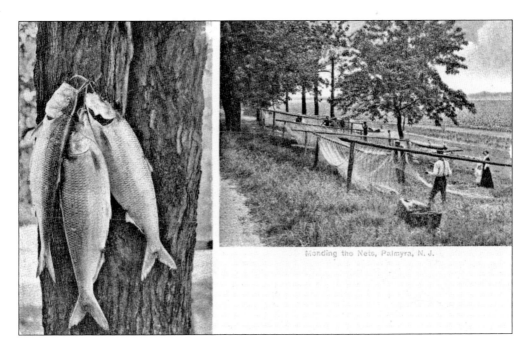

Mending the Nets, Palmyra, N. J.

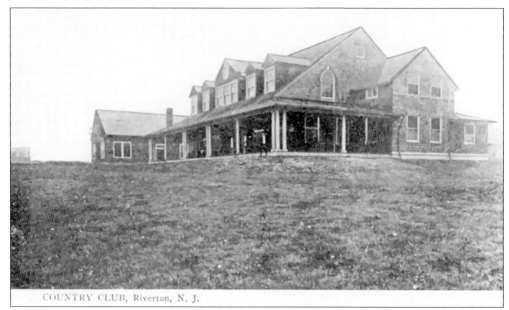

COUNTRY CLUB, Riverton, N. J.

In 1900, Ezra Lippincott and Edward H. Ogden were the originators of the plan to establish the Riverton Country Club, one of the earliest golf clubs established in the United States. Within months, a nine-hole course was devised on the 62-acre grounds. Ogden was its first president. However, James S. Coale, a great lover of sports who built his home at 805 Thomas Avenue in order to be close to the club, was the main reason for the club's early success. The vintage postcard above shows the building at the start of the 20th century. Below, a still from *The Romance of Riverton* captures a golfer practicing his stroke in 1926.

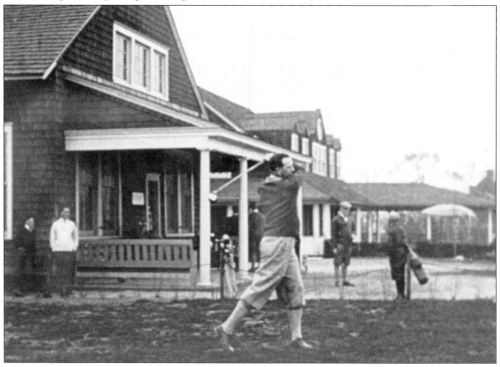

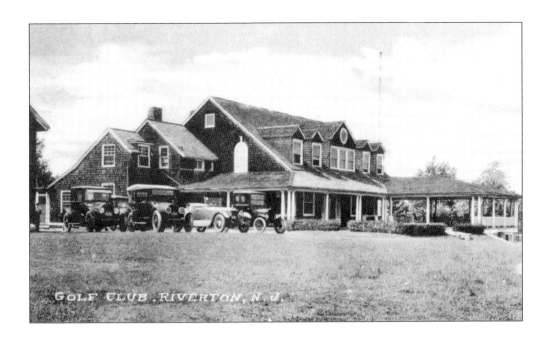

The original Riverton Country Club clubhouse on Park Avenue included a broad, comfortable porch. Expanded to 18 holes in 1917, the club's golf course still plays an essential part in the community, with deep roots in providing players of all skill levels and ages a chance to excel in this wonderful old sport, as shown in the 1926 image (below) of the youth team.

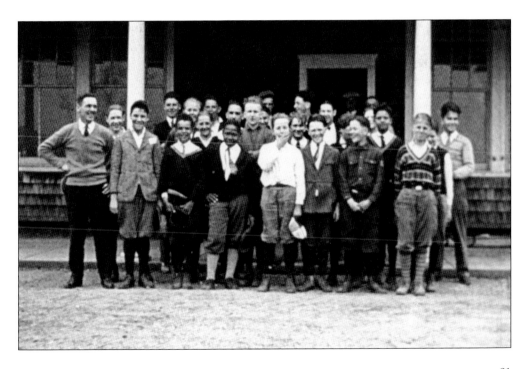

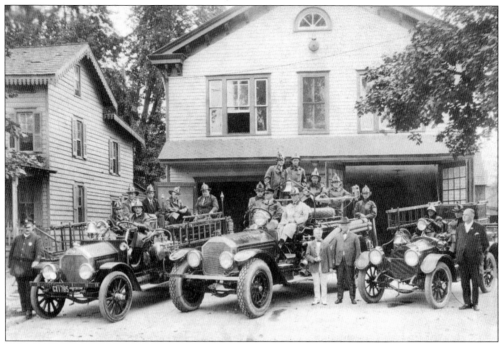

In 1890, the Riverton Volunteer Fire Company was formed after a disastrous fire that destroyed Roberts' Store, another store, and several residences at the point where Main and Howard Streets meet. John C.S. Davis of 505 Bank Avenue was elected the company's first president. At first, resident Charles Rienhard simply raised the alarm by "yelling at the top of his lungs." In 1891, the fire company paid $2 to the first man to arrive with a horse with which to pull the chemical engine. Since 1897, the fire company has played a significant part in the Fourth of July parade.

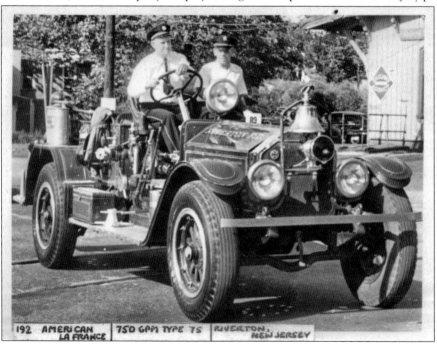

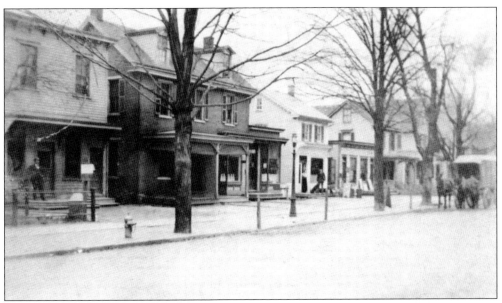

The first fire drill of the newly formed Riverton Volunteer Fire Company was held in the late summer of 1890 at a plug located on Lippincott and Bank Avenues. The borough bought 50 badges for the firefighters—an endorsement of its gratitude for their service.

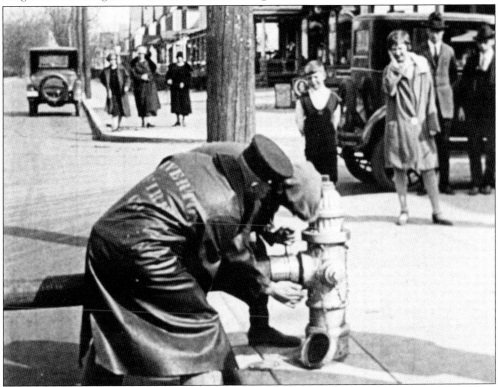

Ever since the Riverton Volunteer Fire Company's first drill in 1890, firefighters have trained frequently and sometimes put on public demonstrations such as this one from the 1926 film *The Romance of Riverton*.

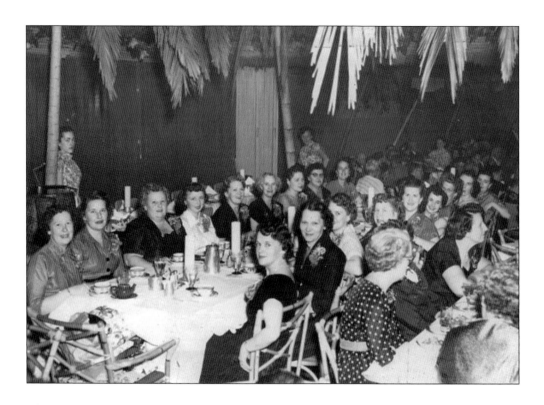

As shown in the 1950s photograph above, the women of the Riverton Firehouse Ladies' Auxiliary enjoyed a social gathering at the Hawaiian Cottage, a popular Polynesian-style restaurant located in nearby Cherry Hill, New Jersey. The ladies provided fundraising and served the community as strong pillars of support for the beloved firefighters and firehouse.

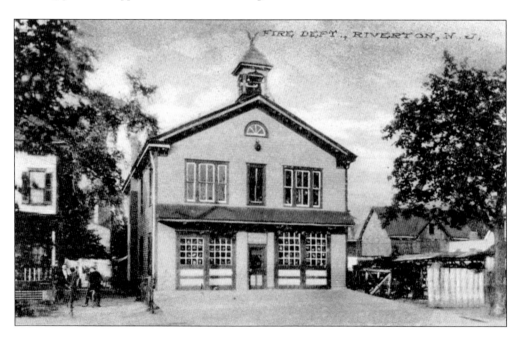

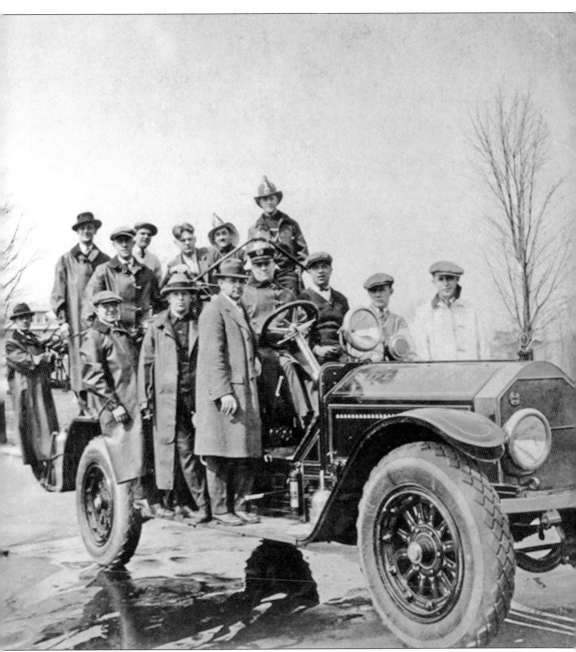

At the annual Riverton Volunteer Fire Company meeting in January 1925, the members elected John C. Geiss as president. Membership then included 313 active and inactive members. At the meeting, they also discussed the need to replace the company's 1922 American LaFrance pumper.

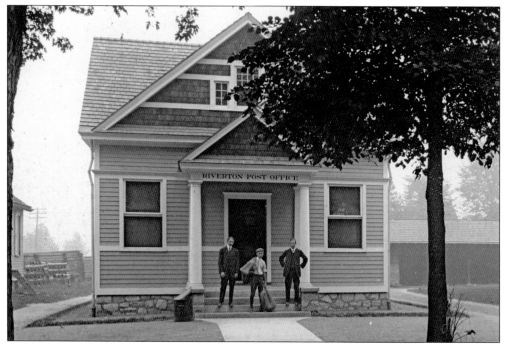

Riverton's first post office was established in 1871 in a station house located at Broad and Main Streets (where the Veterans Memorial now stands). Later, mail service moved to Cowperthwait's Drug Store on Main Street. After two other moves, it was relocated to 609 Main Street in a building (above) that had been the Episcopal church Sunday school building. Home mail delivery started in 1920. Two moves later, the big brick post office at 613 Main Street served from 1940 to 2009; a downsized USPS facility has operated from commercial leased space at 605 Main Street since.

Next door to the post office, the Cinnaminson National Bank built a beautiful new structure in 1907; it still stands today.

In 1886, "dissatisfaction was very marked" when Riverton's first frame schoolhouse, located at Fourth and Howard Streets and built 30 years earlier, could not accommodate an overflow crowd of ticket-holders attending a special event. That night, Riverton's Stephen Flanagan offered a plot of land at Fourth Street and Church Lane for the construction of a new building for public entertainment, lectures, dances, fairs, and more. Over the next 30 years, the gossip and society pages of the *Philadelphia Inquirer* and the *New York Times* noted Riverton's wealthy residents and some of the best families of Philadelphia attending dances and other social and educational events at the Riverton Lyceum. The building hosted its last event in 1917 and burned down in 1918.

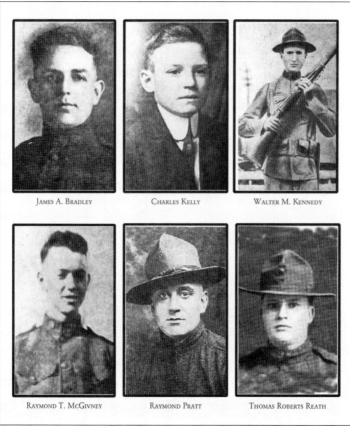

JAMES A. BRADLEY

CHARLES KELLY

WALTER M. KENNEDY

RAYMOND T. McGIVNEY

RAYMOND PRATT

THOMAS ROBERTS REATH

It is no surprise that the devotion to peace runs deep in Riverton, a town founded by Quakers. Residents responded in myriad ways to help resolve conflicts in the larger world, and many of them served in the armed forces. These six young Rivertonians lost their lives in World War I. In memory of these Gold Star men, Riverton planted six sycamore trees on the streets around Riverton School; the trees still stand today.

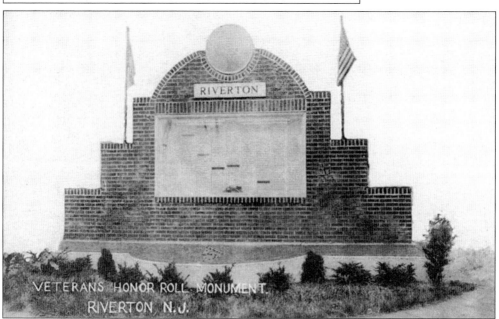

After World War II, the citizens of Riverton built a special memorial to honor those who served in the war. It was later updated to include the names of those who defended the country in all wars.

Six

HOUSES OF WORSHIP

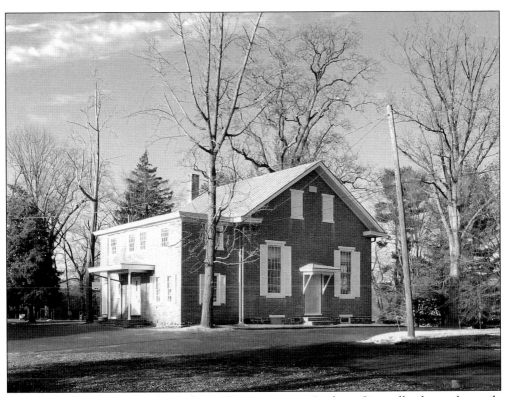

Most of the founders and early residents of Riverton were Quakers. Generally, those who made Riverton a summer home continued to worship in their home meetings in Philadelphia. Most of the others belonged to the existing Westfield Meeting about two miles away, which is shown as it stands today. Founded in the late 18th century, it is still active today and located at what is now Riverton Road and Route 130 in Cinnaminson. The large but modest cemetery serves as the final resting place for many Rivertonians.

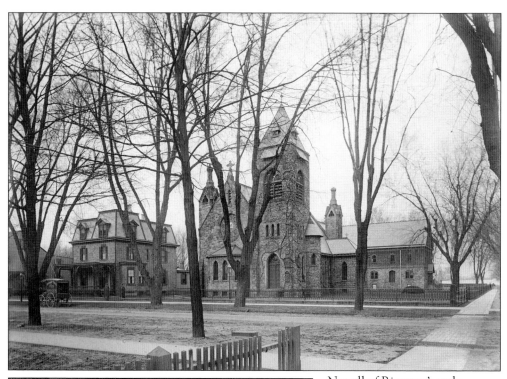

Not all of Riverton's early residents were Quakers. Episcopalian residents formed the parish of Christ Church in 1855. The first small frame buildings and a cemetery were located on Broad Street at Church Alley near Main Street. They were moved several times and replaced in 1884 with this stone edifice designed by local architect John Fraser. The original frame church still stands and is now located at Parry Avenue in Palmyra.

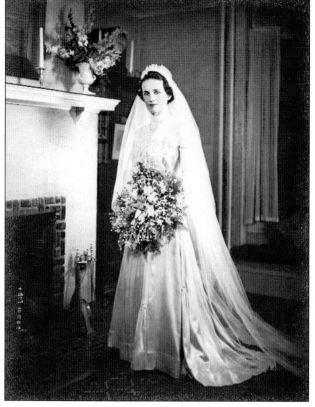

A number of Quaker families turned toward the Episcopal Church in subsequent generations; the Parrish family was one of them. Alice Lippincott Parrish Hackett is pictured on her wedding day in 1938.

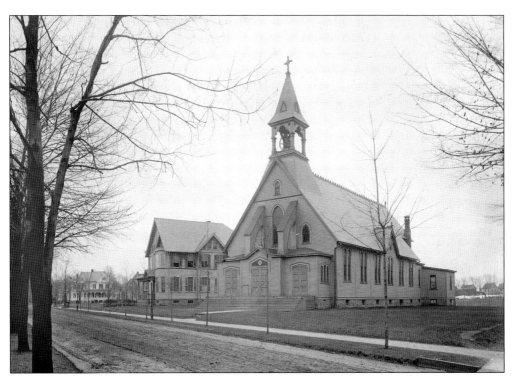

Many of the earliest members of the congregation of Sacred Heart were Irish Catholic immigrants on the household staffs of wealthy Philadelphians who owned the riverbank villas. In 1874, they celebrated the first Catholic Mass in Riverton. Some of the names recorded as in "attendance continually and most firmly dedicated to the work of the Lord" in early years are the sisters McCreely, Catherine McLyndon, Lizzie Roe, and Margaret Harty. The first chapel was small and located on Fourth Street between Howard and Main Streets. The church laid the cornerstone of a splendid frame building (above) in 1892. Between 1914 and 1934, the parish added its first convent and school. The frame church was closed in 1963, demolished, and replaced with today's larger brick church (right).

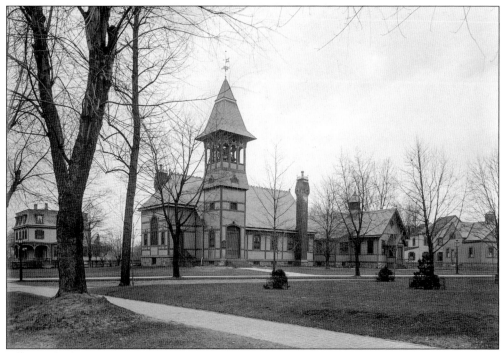

The members of Calvary Presbyterian Church, which was established in 1874, first met on porches, then in the school, and finally in a small chapel built on land donated by Edward Lippincott on the corner of Fourth Street and Lippincott Avenue. The church secured the lot in 1887 and built the structure shown here, which was designed by Philadelphia architect John Fraser. In 1926, architect George Savage transformed it with Gothic stone cladding and a new stone bell tower. Early members included Joseph Campbell, founder of Campbell Soup; William Dreer, owner of a large nursery; and Fraser.

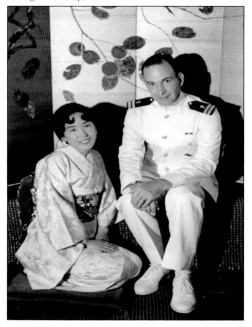

After his stint as a US Navy line officer and chaplain, Richard C. Moore and his wife, Toshii, moved to Riverton. Richard served as pastor for the Calvary Presbyterian Church congregation for 27 years beginning in 1966. Richard's tenure in Riverton developed him into a serious artist whose forte was ship and maritime compositions.

By the mid-1920s, the congregation of Calvary Presbyterian Church had outgrown the building's seating capacity, and improvements were necessary. The original sanctuary (pictured) was saved but expanded in the chancel with two additional transepts, and an assembly space was extended from the opposite end. Connected to this, a new Christian education wing replaced the earlier chapel, the bell was moved, and the entire facility was sheathed in stone to revise the church's appearance to an English Gothic Revival style.

Mt. Zion AME Church began in 1897 when Alice Taylor, president of the local Missionary Society, organized the Riverton African Methodist Episcopal Mission, which first met in Roberts' Store at Main and Howard Streets. Renamed Mt. Zion in 1908, the church moved into a new building at Fourth and Penn Streets with the first pastor, Rev. W.H. Gassaway. Mt. Zion has always served as the heart of Riverton's close-knit black community.

The family members of Dr. Clarence B. Jones were stalwarts of Mt. Zion. Jones was a pivotal figure in the Civil Rights Movement as personal counsel, speechwriter, and close friend of Dr. Martin Luther King Jr. King (foreground) and Jones (standing behind King) are pictured in Birmingham, Alabama, in February 1963. When Jones's father passed away in December 1962, Dr. King came to Mt. Zion and spoke at his funeral two months before the famous March on Washington. (Courtesy of Ernst Haas/Getty Images.)

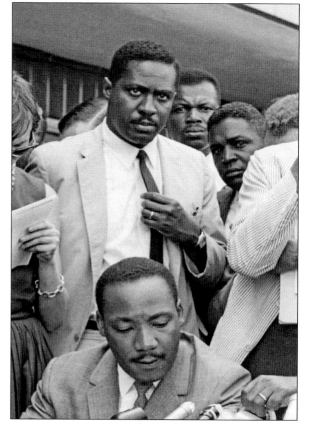

Seven

GETTING AROUND TOWN AND BEYOND

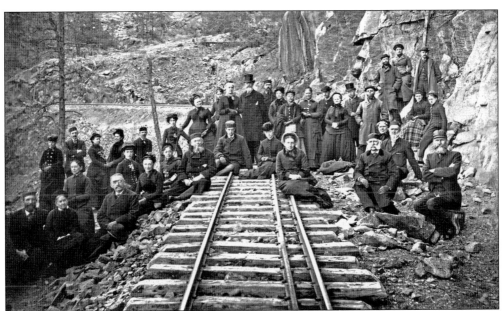

In 1886, a large group of adventurers traveled from Riverton to San Francisco, California. The detailed account of their brave journey is recorded in several colorful letters they sent home. They traveled by rail, horse, foot, and carriage to experience the American West in a unique and significant way. Among them were members of the Spackman, Coale, and Ogden families, as well as Elizabeth Campbell.

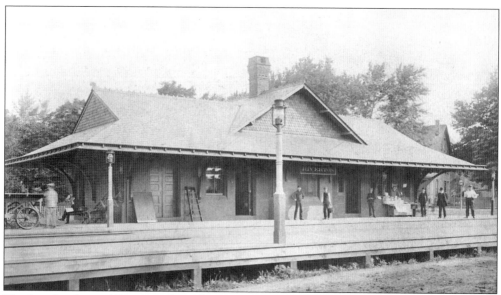

The founders located Riverton along the Camden & Amboy Railroad, one of the oldest lines in the United States, which later became part of the Pennsylvania Railroad. The second Riverton train station (pictured in the late 1880s) was literally and figuratively the heart of the town. The railroad slowly replaced steamboats as the primary method used by residents to travel and send and receive packages and freight. Multiple daily trains connected Riverton to the world.

Albert Yearly (left) and an unidentified girl play by the tracks where Cedar Street crosses the railroad. The shed on the right (now located in Memorial Park) was used to store tools and materials for track maintenance, including the handcar shown here.

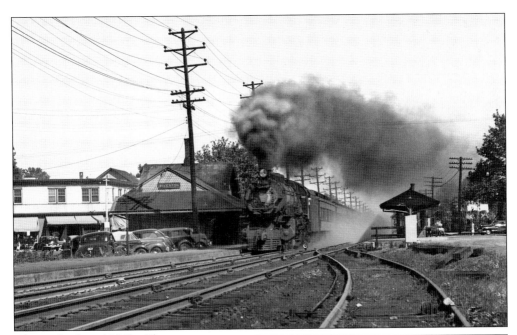

Above, the famed Nellie Bly, a New York City–Atlantic City express train named after a globe-trotting reporter, thunders past the Riverton station at a speed of 60 mph around 1938. The speedy commute came at the expense of occasional fires started by embers discharged from the steam locomotive's chimney and sometimes horrific collisions at railroad crossings.

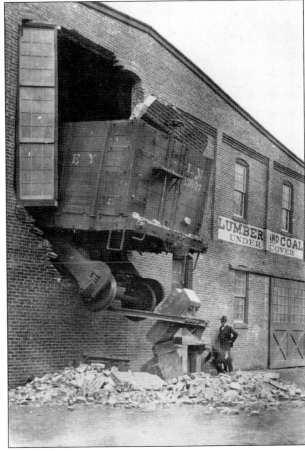

Railroading was dangerous, and accidents were common. This building (now gone) between Lippincott Avenue and Main Street held the indoor coal bins for Collins Coal and Lumber, which had a main building at 600 Main Street that still exists. The siding went up a steep ramp that started its climb at Lippincott Avenue and Little Broad Street.

Like most streets in Riverton in the early 1900s, Thomas Avenue had curbs but was unpaved. As befits a well-planned community, the wide streets were both elegant and practical.

Members of the Yearly family delight in the snow in their horse-drawn sleigh on Cinnaminson Street around 1900. With unplowed streets, sleighs could glide along on top of the snow and ice.

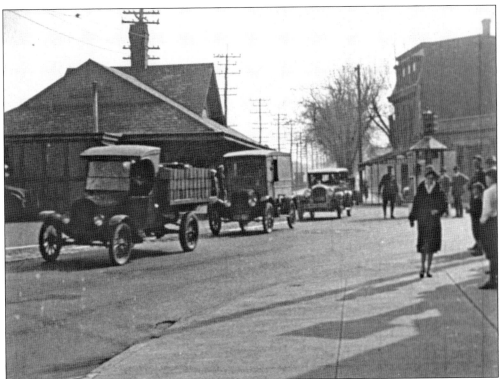

These stills from the film *The Romance of Riverton*, made in the spring of 1926, show several means of travel in that booming era, as automobiles were suddenly much more affordable. Rules for traffic were just beginning to be formed. For those without cars, the frequent and cheap electric trolley offered a simple way to go from town to town—or as far as Trenton or Camden. Trolleys ran through the area from about 1902 until they were replaced by buses in 1931.

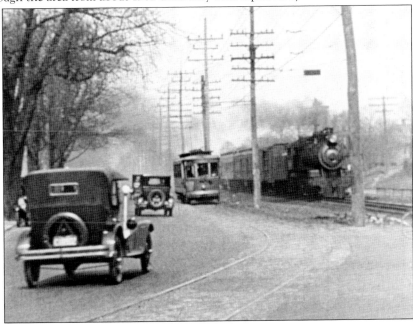

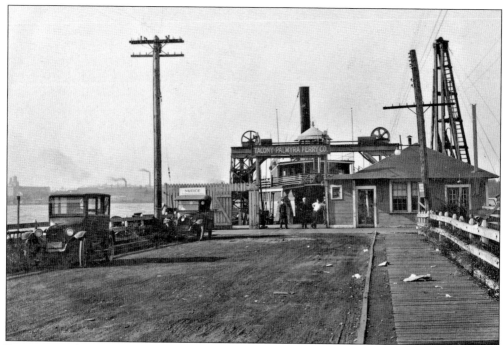

Riverton resident Charles A. Wright championed a river crossing between Tacony and Palmyra. The Tacony-Palmyra Ferry opened for business on May 1, 1922. Each of the first two boats accommodated 36 vehicles and 500 passengers. The ferry ceased operation after the opening of the Tacony-Palmyra Bridge in 1929.

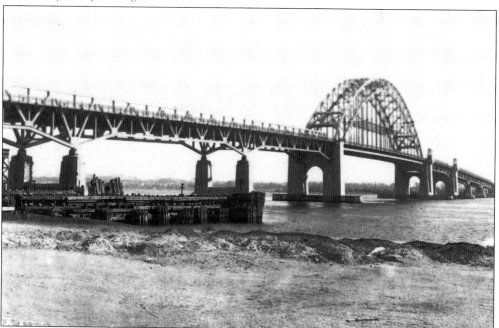

Charles A. Wright was the originator of the movement to build the Tacony-Palmyra Bridge. Construction started on March 27, 1928, and the bridge opened on August 15, 1929—the culmination of a longtime dream.

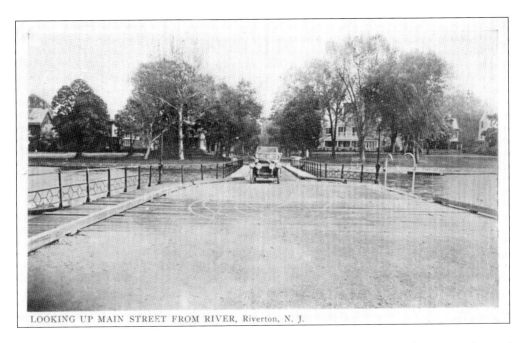

LOOKING UP MAIN STREET FROM RIVER, Riverton, N. J.

As automobiles became more accessible, people started to make them their main form of transportation in town and beyond. The c. 1920 view above looks up Main Street from the Riverton Yacht Club pier. Bill and Nancy Hall bought the used 1947 Ford "woody" wagon (pictured below with Bill) and later said they always regretted selling it.

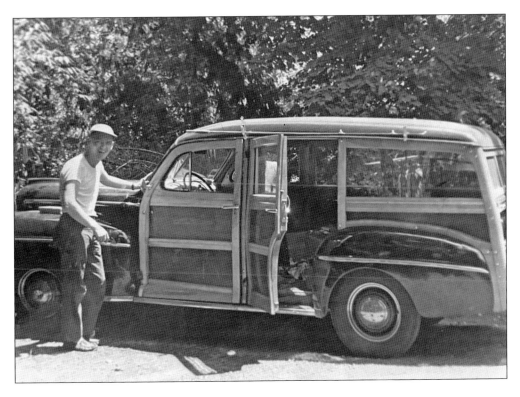

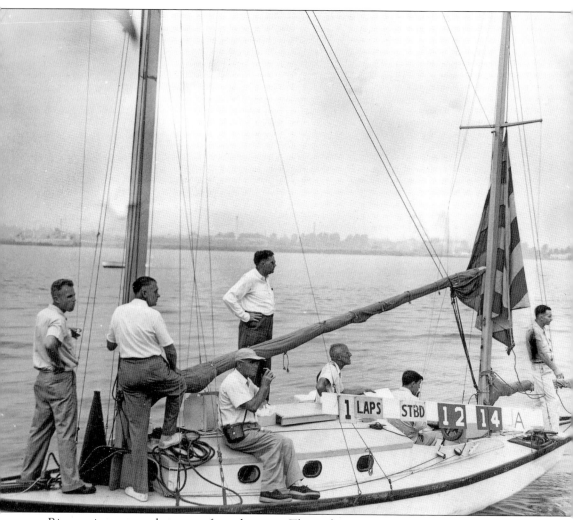

Rivertonians cannot keep away from the water. This is the Riverton Yacht Club Race Committee probably running a Duster race on a very light air day in 1951. Does it take a committee of seven? Of course not, but what better excuse to be on the water? Be it on road, rail, trail, or wave, the people of Riverton will find a way to enjoy every minute of the journey.

Races are more exciting with local fans cheering from the Riverton Yacht Club perches and docks or from the seawall. Regardless of if one is watching a race or just looking at the boats passing by, this has been an enjoyable pastime for decades, as illustrated in this 1950s photograph.

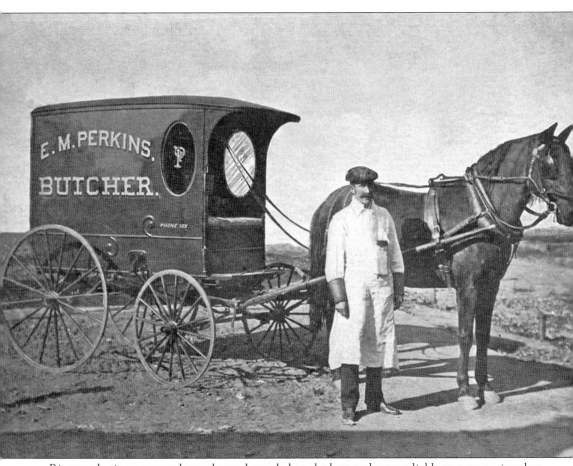

Riverton business owners have always depended on the best and most reliable transportation they could afford. Much like today, they also utilized creative opportunities to succeed. Ezra Perkins erected the house at 608 Main Street in 1889 and then built a small adjacent structure at 606 Main Street around 1900 to serve as his butcher shop.

Eight

EARLY COMMERCE

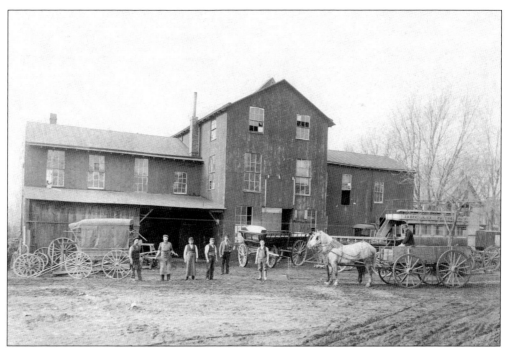

The C.T. Woolston Carriage Works at Seventh Street and Lippincott Avenue built a variety of wagons and carriages, including a double-deck omnibus (visible in the background at right). After the demand dried up for wooden, horse-drawn vehicles, Penn Motors used the site to build a car named the Hilton. This structure burned down in a fierce fire in June 1921. Today, four homes stand in this location.

Adjoining the Joseph M. Roberts' Store on Main Street in 1890, Wolfschmidt's "new tonsorial parlor" offered the latest brands of cigars, all kinds of chewing and smoking tobacco, and snuff. In 1919, Emerson Wolfschmidt boasted of "two barbers—no waiting" and offered Wildroot Hair Tonic for 60¢ a bottle.

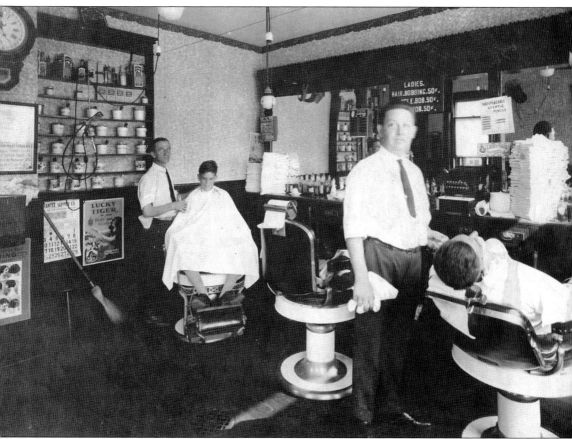

Inside the walls of Wolfschmidt's barbershop was a staff of ready barbers who could not only trim hair but created a good environment for men to socialize, hear the daily news, and gossip with one another. In this picture taken at Wolfschmidt's later Howard Street location, Emerson Wolfschmidt Jr. stands at the first chair on the right; Edward Moorhouse is at the third chair on the left. The young men in the chair at 5:34 p.m. on this day in August 1925 are unidentified. At that time, a haircut cost 35¢ and a shave was 15¢.

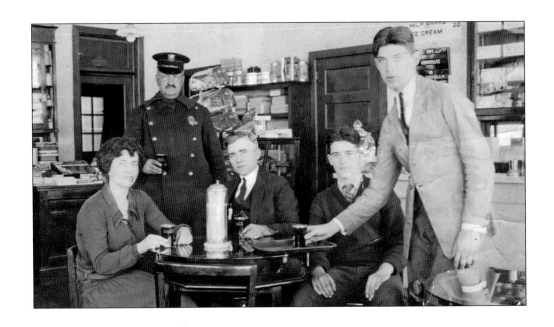

Keating's Drug Store was a Riverton staple for decades. Pictured above around 1924 are, from left to right, Blanche Keating, officer Walter Miller, Lawrence Keating, Chick Seagrave, and Harry Herman. Keating's, located on the corner of Broad and Main Streets, was a very popular place for people to have a soda or ice cream.

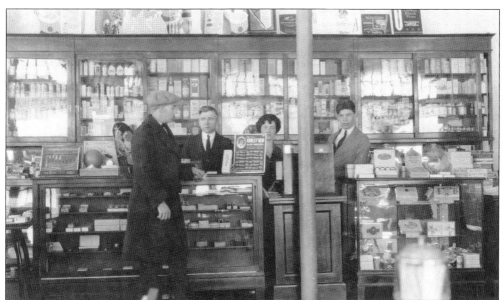

The counter at Keating's Drug Store was a familiar haunt of residents who enjoyed fountain favorites and a social destination for many years. More than a few locals recollect how owners Lawrence and Blanche Keating would place a rectangular dish made of heavy cardboard on a scale, scoop ice cream into it, place a piece of tissue-like paper over the top, and then place it into a brown bag for the customer to take home. Lawrence and Blanche (pictured at right) lived with Lawrence's widowed mother, Katherine, on River Road in East Riverton.

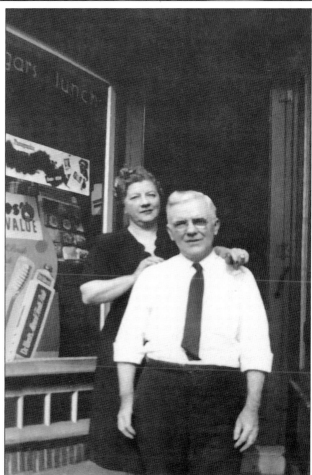

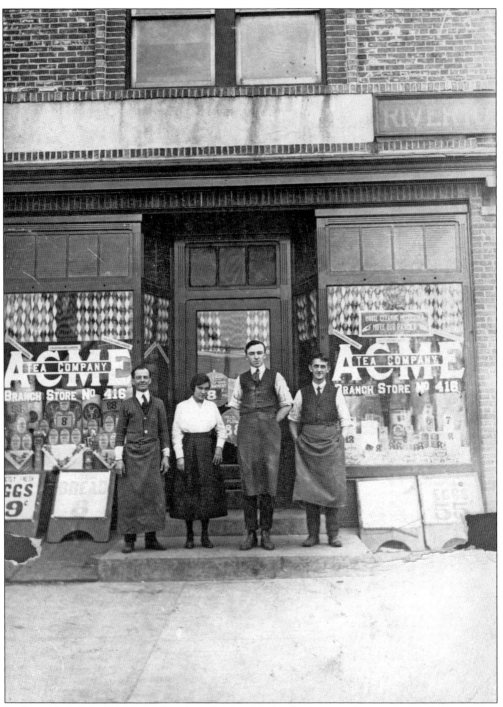

In the early years of Riverton, the idea of a supermarket had not yet been conceived. Storefronts like this had pretty much every kind of grocery item one might need, and Riverton had several—some independent, some not. This is the Acme Tea Company (the predecessor to today's Acme) in the Collins building at 600 Main Street, one storefront away from Harrison Street.

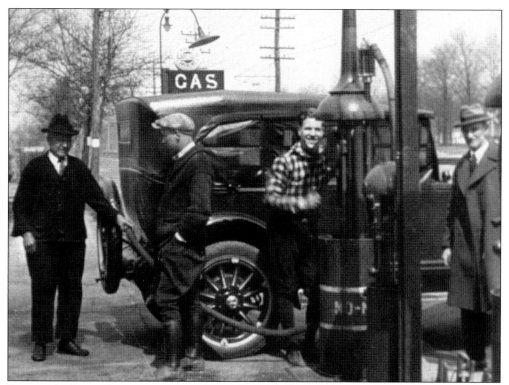

Riverton had several service stations where one could fill up on gasoline or have repairs performed on the automobiles that had flooded the roads in the 1920s. This is the happy crew at Taylor's Garage, located on the corner of Broad and Fulton Streets, in a frame from the 1926 film *The Romance of Riverton*.

Ernest Chew, a confectioner and baker with a storefront at 512 Main Street, was known for his ice cream and "lady locks"—a delectable filled pastry. Ernest and his family lived upstairs on the premises, which was not an uncommon arrangement.

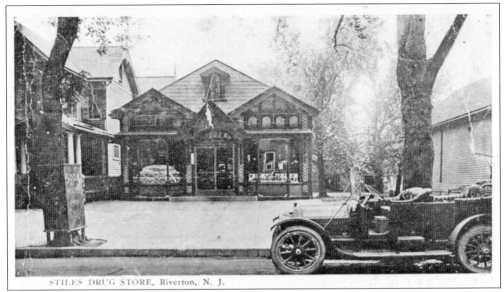

STILES DRUG STORE, Riverton, N. J.

William Stiles bought the old butcher shop at 606 Main Street in 1910, promptly leveled it, and built a "thoroughly modern drugstore and soda water fountain." It was under new management in 1929 as Blankenbush Pharmacy. Freeman Hunter later operated a fine furniture store here for over 30 years, and it became the New Leaf plant and gift shop in 1979. Since 2003, it has been home to the New Leaf Tea Room.

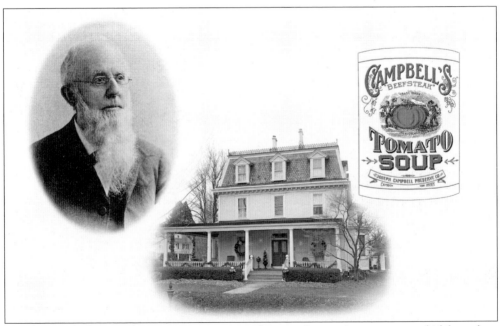

Joseph Campbell's name became synonymous with canned soup. A poor country kid from deep South Jersey, he was so successful in building his preserved vegetable and fruit business that he was able to buy this magnificent home at 308 Main Street in 1872. He lived in Riverton until his death 30 years later.

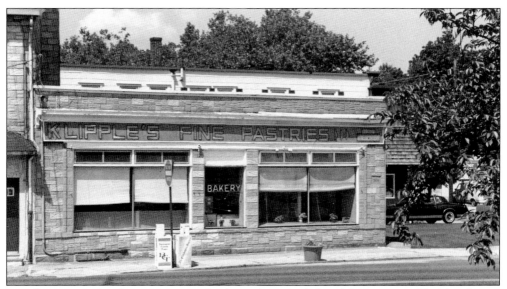

Standing at Broad and Main Streets, Klipple's Bakery was beloved for its cream-filled doughnuts, sugar cookies, twists, onion and snowflake rolls, and butter cakes. Klipple's, which was open from approximately the 1950s to the 1980s, was always part of school walking trips. Owner Leroy "Roy" Klipple showed students how everything was made, then gave out doughnuts.

Frank C. Cole (pictured around 1920) started with a stand on Cinnaminson Street in 1896 and established a local distribution facility at 501 Main Street in 1903 for products trucked in from regional dairies. During the Depression, Frank's 13-year-old grandson Francis "Franny" Cole helped with the family business. Jogging alongside the truck, Franny delivered glass quart (15¢) and pint (10¢) bottles of fresh dairy products to households across Riverton, Palmyra, Cinnaminson, and Delran. The business closed about 1940.

Richard D. Barclay was one of the first people in New Jersey to realize the need for bees to pollinate food crops. In 1901, a teenage Barclay took over the management of bees on the Lippincott farm, working with them on school vacations and building up a large colony; by the 1930s, he owned the largest apiary in the east and established himself as a national authority on bees. In 1914, he married Joseph Campbell's granddaughter Theresa Spackman, and they lived at 205 Lippincott Avenue. Dreer's Nursery engaged Barclay in 1929 to put three colonies in a field of scarlet sage. The result was that they gathered nearly three times the amount of seed from the field that contained bees than from a larger field with no honeybees.

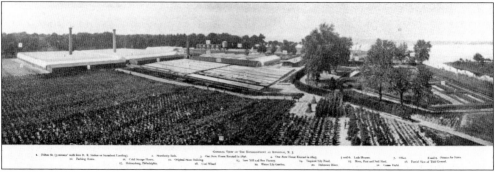

Henry A. Dreer founded his florist business in Philadelphia in 1838, and it grew into an internationally acclaimed seed, plant, and bulb firm that flourished for over a century. In 1873, Dreer moved his greenhouses from West Philadelphia to 300 acres in Riverton along the Pompeston Creek. Generations of locals worked in Riverton's only major industry. Dreer's Nursery closed in 1944, and part of the land it occupied was developed into housing lots.

"VICTORIA TRICKERI" LILY POND, DREER'S NURSERIES, RIVERTON, N. J.
(The leaves of these lilies average 5 feet in diameter.)

A child stands in one of Dreer's Nursery's most interesting aquatic exhibits—the water lily ponds. At the 1904 St. Louis horticulture exhibition, the grand prize was awarded to Dreer's for these specialized plants. Some of the basins measured 10 by 25 feet and had a few goldfish to maintain the health of the plants and low levels of mosquitos.

U S. DEPARTMENT OF AGRICULTURE, COOPERATING WITH NEW JERSEY AND PENNSYLVANIA DEPARTMENTS OF AGRICULTURE

THE JAPANESE BEETLE

LEARN TO RECOGNIZE IT

ENLARGED 4½ TIMES, SHOWING NATURAL COLORS OF THE BEETLE

NATURAL SIZE

THE beetles appear during the middle or latter part of June, but are most abundant and active during July and August. They feed on fruit, foliage, and blossoms of most cultivated crops, as well as many shade trees and common weeds of field and roadside. If you find the insect in your locality, report it to the

JAPANESE BEETLE LABORATORY
RIVERTON, N. J.

GOVERNMENT PRINTING OFFICE

Dreer's Nursery was infamous for being the carrier of the destructive Japanese beetle, shown here on a rare pest identification card from Paul Schopp's collection. In 1916, the nursery discovered the beetle on the premises, apparently having arrived in the grub stage some years prior in the root balls of some iris plants imported from Japan. The beetles rapidly became a widespread pest.

125

In 1933, Riverton became the birthplace of the drive-in theater when 33-year-old Richard Hollingshead Jr. invented a way for his mother to enjoy motion pictures in a location other than an uncomfortable theater seat. Experimenting with a Kodak projector at his home at 212 Thomas Avenue, Richard devised a method for showing movies outdoors that provided parking spaces with enough elevation to view the screen without being blocked by other vehicles. The patent was granted in 1933, and the first commercial version was built on Admiral Wilson Boulevard in Pennsauken, New Jersey.

Watch the Movies From Your Auto

Cross Section, Showing Method of Placing Cars

An artist's conception of the first automobile movie theatre in the world, the Drive-in Theatre, located on the Admiral Wilson Boulevard near Central Airport, in Camden, invented by Richard M. Hollingshead, Jr., of Riverton. It will be open to the public early next month. Motor cars are virtually transformed into private boxes making it possible for motorists and their guests to see and hear the movies without leaving their cars. They are permitted to smoke, chat or even partake of refreshments. The Camden Drive-in Theatre occupies a space approximately 250,000 square feet. Above a cross section view showing two of the seven rows.

The first film shown at the first drive-in theater was a British comedy, *Wives Beware*, starring Adolphe Menjou. Eventually, the drive-in concept proved to be a success, but it did so without benefiting Hollingshead. After his patent was overturned in 1949, the number of drive-ins increased, and it peaked in the late 1950s and early 1960s.

The Historical Society of Riverton invites readers to learn more about Riverton and its rich history. Please keep in mind that much of the physical material upon which the society depended for compiling this book about Riverton's past came from family albums, scrapbooks, a forgotten trunk, or a grandmother's attic. The public's participation in this process is vital to increasing the understanding of Riverton's past. The society hopes to better illuminate some of the incomplete parts of the area's historical record and thanks the supporters of its preservation efforts. The society's website can be accessed at rivertonhistory.com, and people can contact the society via email at rivertonhistory@gmail.com. (Courtesy of Bettmann/Getty Images.)

DISCOVER THOUSANDS OF LOCAL HISTORY BOOKS FEATURING MILLIONS OF VINTAGE IMAGES

Arcadia Publishing, the leading local history publisher in the United States, is committed to making history accessible and meaningful through publishing books that celebrate and preserve the heritage of America's people and places.

Find more books like this at
www.arcadiapublishing.com

Search for your hometown history, your old stomping grounds, and even your favorite sports team.